Introduction by David W. Steadman
Catalogue by David W. Steadman and Carol M. Osborne

18TH CENTURY DRAWINGS FROM CALIFORNIA COLLECTIONS

Montgomery Art Gallery
Pomona College
Claremont
January 16-February 29, 1976

The E. B. Crocker Art Gallery
Sacramento
March 14-April 11, 1976

Galleries of the Claremont Colleges
Pomona College Scripps College

This exhibition and catalogue were supported by grants
from the California Arts Commission and Edward Lasker.

Designed in Los Angeles by Lilli Cristin. All text set in
Garamond by Ad Compositors. The catalogue is printed on
Lustro Offset Enamel Book and Sonata Kidskin Cover
by Precision Graphics, Los Angeles.

Cover: *Head of a Roman Soldier,* by François Boucher

The catalogue entries are arranged alphabetically
by artist. The illustrations are in approximately
chronological order.

Lenders

Mr. Rudolf Baumfeld
The E. B. Crocker Art Gallery, Sacramento
Mr. and Mrs. Lorser Feitelson
Fine Arts Museums of San Francisco
The Grunwald Center for the Graphic Arts, Los Angeles
Los Angeles County Museum of Art
Santa Barbara Museum of Art
The Norton Simon Foundation, Los Angeles
Stanford University Museum of Art
University Art Museum, University of California, Berkeley
Private Collections

Foreword

The year 1975-1976 has been designated "Festival Year: Enlightenment and Revolution" at Pomona College. A number of events — among them symposia, lectures, and performances of Mozart's *The Magic Flute* — will concentrate on these two central themes of the eighteenth century. This exhibition is the contribution of the Galleries of the Claremont Colleges to Pomona College's Festival Year.

1975-1976 is also an important year for drawings in California. In October and November of 1975 the University Art Museum, Berkeley, and the Stanford University Museum of Art cooperated in *The Age of Turner*. The Henry E. Huntington Art Gallery displayed a large number of their 590 Rowlandson drawings from November to January. In March and April of 1976 the exhibition *William Blake and the Art of His Time* at the University Art Museum, Santa Barbara, will be the focus of a symposium; a parallel exhibition, *The Followers of Blake,* will be at the Santa Barbara Museum of Art. Finally, in April the Los Angeles County Museum of Art will open its first major drawing exhibition with more than 200 master drawings from American collections.

The year 1975 will see the publication of a new catalogue by Alfred Moir devoted to the drawings of the Santa Barbara Museum of Art and another in 1976 by Phyllis Hattis devoted to the collection of French drawings of the Fine Arts Museums of San Francisco. The E. B. Crocker Art Gallery, Sacramento, will publish a monograph by Seymour Howard on their drawing *Funeral of a Warrior* by Jacques-Louis David. Other publications on drawings in California collections can be found in the list of abbreviated titles or in the individual entries. Two other books should be noted: *Selections from the Drawing and Watercolor Collection,* Mills College, Oakland, 1972 and *Old Testament Narratives in Master Drawings,* edited by Seymour Howard, The E. B. Crocker Art Gallery, Sacramento, 1973. Robert Wark has written many books on the English drawings in the collection of the Henry E. Huntington Library and Art Gallery. Some of the eighteenth-century continental drawings in the Huntington collection are included in Marcel Roethlisberger's *European Drawings from the Kitto Bible,* 1969.

Several drawings in the exhibition will be on display only at Claremont. These are catalogue numbers: 17, 18, 22, 23, 27, 32, 35, 47, 48, 49, 58, 62, 63, and 64. Catalogue number 39 will be on display only in Sacramento. The exhibition will be further supplemented by sixteen drawings from their collection when the exhibition is at The E. B. Crocker Art Gallery.

Carol M. Osborne, formerly slide librarian of the art department, Pomona College, has written the following entries: Anonymous French, Bartolozzi, Baumgartner, Benard, Bergmüller, Boucher, Chodowiecki, Cochin, David, School of David, Dietrich, Gainsborough, Ghezzi, Gravelot, Holzer, Lancret, Lemoine, Le Paon, Le Prince, Moitte, Morland, Oeser, Romney, G. B. Tiepolo, and Zick. I am responsible for all of the others.

We would like to thank the many lenders to this exhibition. They have all enthusiastically supported the exhibition through the generosity of their loans. We wish to express our gratitude to Edward Lasker, a trustee of Pomona College, and the California Arts Commission for their generous support both of the exhibition and catalogue. We would particularly like to thank Phyllis Hattis and Alfred Moir who permitted us to use their material many months before the publication of their catalogues. The good advice of Robert Wark has been very helpful to both of us. Seymour Howard, Thomas Pelzel, Gerald Ackerman, and Steven A. Nash have kindly shared their knowledge and insights on individual drawings. Lorenz Eitner, Betsy Fryberger and Ebria Feinblatt have gone out of their way to help us, as has Joan Edwards. Richard West and the staff of The E. B. Crocker Art Gallery have been especially cooperative in helping us obtain a large number of photographs, ultimately not used in the catalogue. Marilyn Pink has been a constant source of encouragement. Joanne Jaffe has edited the manuscript, and Lilli Cristin has been responsible for the design.

David W. Steadman
Director

In the opening years of the eighteenth century, drawings, which hitherto had been considered a somewhat minor form, began to assume a far more significant place in the hierarchy of the arts. Pierre Crozat, a Parisian banker and art collector, amassed the first major collection of drawings in a century which later became known for its fine drawing collections. In the second decade of the century the young painter Antoine Watteau went to live in Crozat's household and there had the opportunity to study this remarkable collection which comprised more than nineteen thousand drawings. Watteau's work soon showed the influence of his studies, and his already superior draughtsmanship assumed a still greater degree of assurance. After Watteau's death in 1721 not only his paintings but many of his drawings, too, were engraved. A precedent was established: for the first time drawings were considered equal to paintings in importance and thus worthy of being included among the major works of an artist.

Pre-eminent among the artists who engraved Watteau's work was the young François Boucher. Later, when he reached maturity, Boucher became first painter to the king and one of the favorite artists of Madame de Pompadour. Like Watteau, Boucher was a superb draughtsman and also an incredibly prolific one, producing more than ten thousand drawings during his long lifetime. Boucher regarded his drawings highly and considered them important enough to exhibit them regularly at the Salon held each year by the Academy.

In terms of French draughtsmanship, the first third of the eighteenth century was virtually dominated by Watteau, the second third by Boucher, and the final third by Boucher's pupil, Jean-Honoré Fragonard. Largely because of the presence and influence of these three artists, Paris, which had become the artistic capital of Europe at the end of the seventeenth century, retained its leading position throughout the eighteenth century. Venice, the second major center for the arts, was dominated by the glorious rococo effervescence of Giovanni Battista Tiepolo. As Austria and Southern Germany recovered from the devastations of the wars of the preceding century, there was a sudden brilliant flowering of artistic life in those countries, too, similar to and as mysterious as that which occurred in seventeenth-century Holland. Holland, however, by the eighteenth century had become basically provincial. England, on the other hand, by mid-century had begun to develop native talent and no longer had to depend on importing leading foreign artists.

The extremely high level of craftsmanship shown even in works of minor artists was one of the most remarkable features of the century. Skill and facility were taught in the academies through laborious copying of casts. It was a painstaking process, but the result was three generations whose skill as draughtsmen was so ingrained that they could almost effortlessly capture the elegance, wit, and intelligence of their age. Indeed, drawings became one of the major vehicles for expressing the niceties of perception and the refinement of thought, a service highly prized by the public. Because of their small size, drawings were also capable of capturing the intimacy and graciousness of life with a new degree of subtlety.

Never before had so many highly finished drawings been made. Preparatory drawings, either for entire paintings or of individual figures, continued to be drawn in abundance, as were detailed drawings intended to be engraved. Increasingly, however, artists produced finished drawings in chalk, ink, or watercolor.

At least in part because the general level of drawings was so high, there were suddenly many collectors eager to purchase them. Crozat was only the first of the long line of drawing connoisseurs during the century. True, drawings had been collected before. In the sixteenth century Georgio Vasari, the first art historian, had systematically tried to collect drawings of all the great artists from the fourteenth century to his own day. But the widespread passion for drawings is an eighteenth-century phenomenon. Long is the list of collectors and includes the names of many artists, among them Pierre Mariette in France, Ploos van Amstel in Holland, Thomas Richardson, Sir Joshua Reynolds, and Sir Thomas Lawrence in England, and the architect Tessin in Sweden.

The practice of framing drawings also originated with Vasari who was the first to draw elaborate frames around each of his drawings. As the appreciation of drawings grew in the eighteenth century, Vasari's precedent was followed. Collectors began to display their drawings with mats, and the French mat — with its series of lines around the drawing and bands of watercolor between these lines — was invented.

Stylistically, the eighteenth century experienced a succession of major changes which touched drawings along with the other arts. In the first quarter of the century the rather heavy formality of the late Baroque gave way to the more

intimate, joyful, and ingratiating Rococo. In painting the *fête galante,* invented by Watteau and widely imitated, established a taste for tender and idyllic landscapes in which people indulge in music and love. The pastorals of Boucher and the amatory paintings of Fragonard amplified this basic theme. In architecture the arts began to merge, and buildings became glorious ensembles of sculpture, painting, and masonry.

The Rococo age in France gave birth to some of the most ostentatious displays of luxury since the Romans. It was customary, for example, to change the fabric coverings of furniture as often as four times a year. Indeed, entire suites of furniture were sometimes changed with the seasons. By the 1770s a reaction set in against the many excesses of the Rococo, and a new severity was introduced into all of the arts. In Paris Peyre's *Odéon* and Ledoux's custom houses marked a return to the simplicity of Greek architecture. In the decorative arts there was a movement away from the curves and arabesques of Rococo decoration toward the incorporation of classicizing motifs. In painting and drawing a new seriousness of style and tone emerged with the Neo-Classicism of Jacques-Louis David.

Also of significance during the eighteenth century was the rise of the middle class. Modeling their tastes on those of the aristocracy, they sought, though on a lesser scale, to indulge in many of the same kind of luxuries. Interestingly, one result was the rapid increase in the demand for books and prints. Illustrated books, large and small and devoted to all subjects, proliferated. Among them was the novel, the new literary form developed by Richardson and Sterne in England and Rousseau in France. Books on the arts, too, were more numerous and permitted the rapid exchange of visual ideas. In England, for example, Lord Burlington's books on Palladio made the plans and elevations of his buildings available to patrons and builders in England and America. In the decorative arts Thomas Chippendale's books on furniture in the 1750s spread the taste for both the Neo-Gothic and Chinoiserie, and the many books on English gardens helped to foster the vogue for this new, less formal type of garden plan throughout Europe. Books on Greek architecture and the discoveries of Pompeii and Herculaneum played an instrumental role in the rise of Neo-Classicism.

The invention of new printing processes also made it possible to achieve faithful reproductions of chalk drawings. These, together with other reproductive prints, could be afforded by the middle class which was now able to derive a pleasure akin to that of the great collectors when they purchased original drawings.

The end of the eighteenth century saw the dissolution of the *ancien regime* and its systems of order: political, moral, and aesthetic. Even more drastically than the American Revolution, the French Revolution in 1789 halted an entire system of government and thought. Like the other institutions, the academies, too, lost their power. Self-training began to replace the more arduous academic training artists had formerly undergone. The level of technical skill in drawing declined rapidly, and an awkwardness crept into the work. It was elevated to a virtue and called freedom of expression. The extensiveness of draughtsmanship of high quality which characterized the art of the century had come to an end.

Literature and Exhibitions Cited in Abbreviated Form

Ananoff, Alexandre. *L'Oeuvre Dessiné de Jean-Honoré Fragonard.* 4 vols. 1963.

Ananoff, Alexandre. *L'Oeuvre Dessiné de François Boucher.* 4 vols. Paris, 1966.

Berkeley, University Art Gallery. *Master Drawings from California Collections.* Editor Juergen Schulz. 1968.

Byam-Shaw, J. *The Drawings of Domenico Tiepolo.* Boston, 1962.

Greco, Joseph. *Rowlandson the Caricaturist.* 2 vols. London, 1880.

Los Angeles, Los Angeles County Museum of Art. *Drawings in the Collection of the Los Angeles County Museum of Art.* Editor Ebria Feinblatt. 1970.

Paulson, Ronald. *Rowlandson, a New Interpretation.* New York, 1972.

Rosenberg, Pierre. "Twenty French Drawings in Sacramento." *Master Drawings.* VIII, 1970, pp. 31-39.

Rosenberg, Pierre. *French Master Drawings of the 17th & 18th Centuries.* Art Gallery of Ontario, Ontario, 1972.

Sacramento, The E. B. Crocker Art Gallery. *The German Masters.* 1939.

Sacramento, The E. B. Crocker Art Gallery. *Master Drawings from Sacramento.* 1971.

Santa Barbara, Santa Barbara Museum of Art. *Drawings from the Collection of the Santa Barbara Museum of Art.* 1970.

Sarasota, Ringling Museum. *Central Europe, 1600-1800.* 1972.

Slatkin, Regina S. Washington, National Gallery of Art and Chicago, Art Institute, *François Boucher in North American Collections,* 1973-1974.

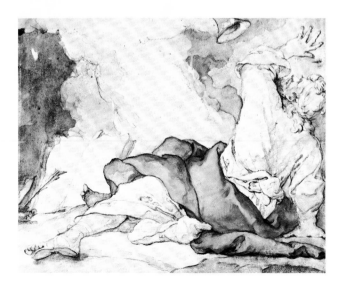

1 Anonymous German, *Man with Book,* black chalk and brown wash, 235 x 289 mm., The E. B. Crocker Art Gallery, Sacramento (592)

Anonymous French, late eighteenth century

1

Castle and House (ill. p. 81)
Watercolor on cardboard
120 x 185 mm. ($4^{13}/_{16}$ x $7^3/_8$ in.)
Stanford University Museum of Art, Palo Alto (64.34)

This unpretentious view of men at work repairing a medieval castle reflects the late eighteenth century's taste for the picturesque. The castle's irregular outline, the roughness of its stones, and the various shapes formed by towers, chimneys, gables, dormers, and steep roofs all play a part in the appeal of this aesthetic.

In the directness of its observation and the charm of its simplicity, the watercolor is close to the work of Louis Moreau (1737-1805), the elder brother of Jean Moreau. His sketches of aspects of Paris and the countryside of the Ile-de-France show the same qualities, completely free of academic convention. They also have the same seemingly casual arrangement of objects like ladders, barrels, and workmen's tools. However, the architecture pictured in the Stanford drawing resembles the half timber construction found in Normandy in towns like Nogent-le-Roi, Lisieux, and Honfleur.

Anonymous German, late eighteenth century

2 *By Dandré-Bardon (P. Rosenberg)*

Prophet Addressing Roman Soldiers (ill. p. 104)
Pen, brown ink, and wash over graphite, heightened with white
191 x 255 mm. ($7^1/_2$ x 10 in.)
Literature: Sacramento, *Master Drawings,* 1971, p. 156 (as Mengs)
The E. B. Crocker Art Gallery, Sacramento (1001)

In addition to the *Prophet Addressing Roman Soldiers,* The E. B. Crocker Art Gallery has in its collection a second drawing by the same anonymous German artist (fig. 1). Both were formerly attributed to Anton Raphael Mengs. (The attribution was probably made by the German dealer Rudolph Weigel, Leipzig, from whom the drawing was purchased.) The drawing, which is far from Mengs' careful style, clearly dates from the end of the century. A variety of influences can be detected. The draperies are an extension of the Rococo; the elongated proportions of the prophet and the strange spatial composition grow out of an interest in Mannerist art. Finally, in the arbitrary distribution of the washes, which create an agitated but irrational sense of excitement in the drawing, the artist's aims are akin to those of the Romantics.

Francesco Bartolozzi
Florence 1728-1815 Lisbon

Francesco Bartolozzi, the prolific engraver of late Georgian art, studied draughtsmanship and design at the Academy of Fine Arts in Florence and was the most outstanding of the engravers trained by Joseph Wagner (1706-1780) in Venice. He is best known for the stipple technique which he popularized in England at the close of the century. He came to London in 1764 at the invitation of Richard Dalton, librarian to George III, to engrave the Guercino drawings in the Royal Collection. In 1768 Bartolozzi was elected a founder member of the Royal Academy.

As a draughtsman and line engraver Bartolozzi displayed remarkable freedom and vigor. But it was the airy and delicate tone of his stipple engravings, many after the pretty designs of G. B. Cipriani and Angelica Kauffmann, that caught the public's fancy. Aided by numerous student assistants, Bartolozzi produced more than two thousand engravings, the most brilliant of which were his reproductions of portraits by Sir Joshua Reynolds. He also did book illustrations, cards, invitations, and benefit tickets for the concerts of his many musician friends among them J. C. Bach and C. F. Abel.

A generous, modest, and hard-working man, Bartolozzi maintained an extravagant household, took snuff, liked spirits, and was passionately fond of music, an enthusiasm he shared with Gainsborough. His improvidence, however, led him to the verge of bankruptcy, and in 1801 to escape his debtors (or to pursue a love affair) he accepted an invitation from the Prince Regent of Portugal to work in Lisbon. He died there in 1815.

3

Portrait of Joseph Rose *(ill. p. 103)*
Red and black chalk
Signed, lower right: *F. Bartolozzi*
127 x 102 mm. (5 x 4 in.)
Los Angeles County Museum of Art, Gift of Solbert Handler (M.69.3)

As an important step in the preparation of an engraving, Bartolozzi would first make his own drawing of the work he was to engrave. This would then be squared for transfer to the plate, as is the drawing of Lord Mansfield at the Huntington Art Gallery after the portrait by Sir Joshua Reynolds. Occasionally, however, Bartolozzi drew from life, as is the case with this portrait of Joseph Rose (1746-1799), Robert Adam's brilliant stuccoist. In 1799 Bartolozzi made an engraving after the drawing (Allessandro Baudi di Vesme and Augusto Calabi, *Francesco Bartolozzi,* Milan, 1928, No. 899); a copy is in Graphisches Sammlung, Albertina, Vienna. This was his only original portrait of the decade.

Johann Wolfgang Baumgartner
Kufstein 1712-1761 Augsburg

Baumgartner, who came from the Tyrol, was one of the most accomplished draughtsmen of his time. His earliest training seems to have been as a glass painter in Salzburg. However, he is best known for the hundreds of designs he supplied to the engravers of Augsburg, a commercial center for the production of the decorative arts during the middle of the century. Baumgartner settled in Augsburg in 1733 after a year of travel through Austria, Italy, Bohemia, and Hungary.

Like Johann Georg Bergmüller, whose student he may have been, Baumgartner also worked as an altar painter and frescoist in Southern Germany. The best known of his church decorations, the ceiling at Baitenhausen, *Schön wie der Mond,* is a light and airy concoction of diminutive figures set against a delicate landscape. Reminiscent of the French Rococo figure style, the fresco is imbued with a love of nature that is characteristically German.

4

Elementum Terrae (Allegory of Earth) *(ill. p. 63)*
Black ink and grey wash heightened with white on blue paper
486 x 686 mm. (19^1/$_{16}$ x 26^7/$_8$ in.)
Exhibitions: Sarasota, *Central Europe,* 1972, No. 66
Literature: Sarasota, *Central Europe,* 1972, No. 66
Fine Arts Museums of San Francisco, The Achenbach Foundation for Graphic Arts (1969.31)

Baumgartner has crowded numerous allegorical allusions into his ornamental fantasy, *Elementum Terrae.* The personification of Earth appears as the female figure seated at the lower center of the drawing. She is accompanied by several of the attributes usually associated with her: the crown of towers which represents her inhabited lands and the waterfall and wood which show the richness of her wilds. In addition, several attributes usually reserved for the personification of Agriculture have been added to her own: the gardener's tools, the basket of fruit, the sheaf of grain, the grapevine, and the symbols for the planets (visible on the metal vessels at the lower right).

Two naturalistic vignettes are included in this image of domestic bounty. At the lower left, newly harvested grapes are being taken to the winepress. In the lower right, miners are at work digging with windlass and pickaxe, perhaps an allusion to the famous local silver industry of Augsburg.

But Earth is not totally benign. She is responsible also for such terrors as earthquakes which cause buildings to topple and men and women of all ages to flee. Like the seasons, which were thought to be governed by the Zodiac, earthquakes, too, were considered the product of astral forces.

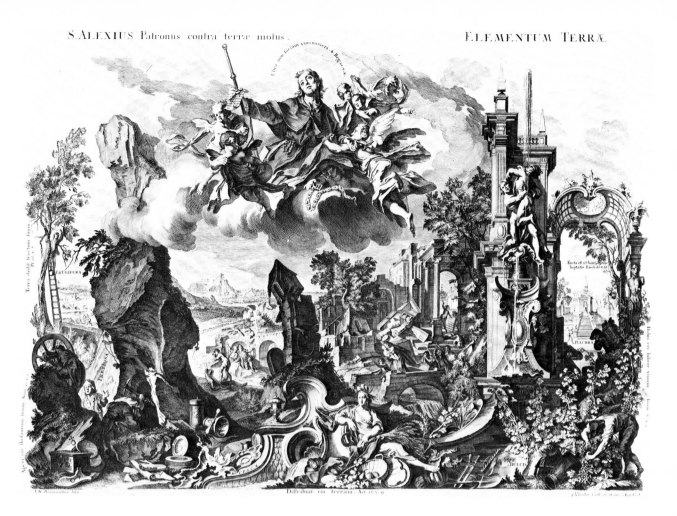

2 *Elementum Terrae*, engraving, the Klauber brothers, Städtische
Kunstsammlungen Augsburg

The conflict between the beneficient and malevolent aspects
of Earth is represented by the struggle of the figures on
the fountain, Herakles and Antaeus, son of Earth. Above
the active scene a saint, thought to be St. Rosalia of
Palermo, the patroness who protects against earthquake
and plague, is wafted heavenward along with the prayers
of mankind. When Baumgartner's design (which has red
chalk on the reverse for transfer) was engraved by the
Klauber brothers (Augsburg, c. 1740-1760), the female
saint was replaced by the male figure of St. Alexius
"patronus contra terrae motus" (fig. 2).

The *Elementum Terrae* was one of hundreds of similar
drawings which Baumgartner designed for the Klaubers
and for the other Augsburg engravers. Three are found at
the Huntington Library in the Kitto Bible (II, fol. 301;
VIII, fol. 1282; XXII, fol. 4106v) and nearly thirty Klauber
engravings are contained in this extra-illustrated book.
However, it was the practice of these engravers to special-
ize not in book publishing, but in ornamental prints. These
were used by craftsmen working in the decorative arts
with silver, stucco, and grillwork. It was in this way that
the Augsburg engravings, with their fanciful ornamental

cartouches, scrolls, and rocaille frames, disseminated the
Rococo style throughout Germany.

Jean Joseph Benard (or Bernard)
Luneville 1740-Paris 1809

The calligraphic portraits of Jean Joseph Benard, a wig-
maker's son, created a sensation in court circles during the
late seventies, but before that time little is known of *"le
fameux Benard."* His career began as calligrapher to
the father-in-law of Louis XV, Stanislas Lesczinski, King
of Poland and, from 1736 to 1766, last Duke of Lorraine
and Bar.

Stanislas had founded a Royal Academy in Nancy where
Benard remained as writing-master to his pages until the
King's death when the school was closed. Twelve years
later he emerged in Paris producing witty pen curlicues,
among them pendants of Louis XVI and Marie Antoinette.
After the war Napoleon reinstated the school for pages
and nominated Benard as its head.

9

3 Dedication page to *Recueil des ouvrages en Serrurie*, 1767, engraving, Cooper-Hewitt Museum of Design, New York

4 Federico Bencovich, *Socrates Encouraged to Escape from Prison*, Bruckenthal Museum, Sibiu

A Visit of King Stanislas Lesczinski to the Atelier of Jean Lamour at Nancy *(ill. p. 65)*
Pen and ink and wash
Signature, lower right: *Chardin*
285 x 475 mm. (11¼ x 17¼ in.)
Exhibitions: Sacramento *Master Drawings*, 1971, No. 91
Literature: M. N. Benisovich, "Stanislas Lesczinski Visiting the Workshop of Jean Lamour at Nancy," *Gazette des Beaux-Arts*, XXII (1943), pp. 57-60; Sacramento, *Master Drawings*, 1971, No. 91 (ill.)
The E. B. Crocker Art Gallery, Sacramento (399)

One of the major examples of urban planning in eighteenth-century France was the Place Royale in Nancy, a handsome square commissioned by Stanislas I, King of Poland. At the four corners of this square are elaborate Rococo grillwork gates cast by the sculptor Jean Lamour, "locksmith" to Stanislas. Lamour chose this memento of his patron's visit for the dedication page of a collection of engraved plates of his Place Royale grillwork (fig. 3). The drawing shows Stanislas looking at Lamour's work with his glass as the sculptor holds up a drawing and points to a pilaster. The elaborate archway at the right is capped by the monograms of Stanislas and Louis intertwined. Since by the time the engraving was ready to be cut Nancy had become part of France, the double monogram of the drawing was replaced by a *fleur-de-lis* on the printed page of the book. Also, as the book was not published until 1767, a year after Stanislas' death, the designs for the grillwork were dedicated to the King's son-in-law, Louis XV.

A variation between the print and the drawing helps to date Stanislas' visit to about 1753. The archway in the drawing is similar to an illustration of 1753 found in Stanislas Heré, *Plans et elevations de la Place Royale de Nancy*. The engraved form, on the other hand, is close to the final version, completed in 1755.

In the text of his book Lamour wrote that the engraving had been done by Dominique Collin after a picture by "Benard, peintre célèbre à Paris." The citation poses a problem, however, for in 1767 when the book was published "Benard" was not yet the fashionable portrait calligrapher he later became. In fact, little is known of him from that time. And, what is more, in 1753, the approximate date of the scene depicted, Jean Joseph Benard was only thirteen years old — an unlikely age for the recorder of this lively, well-observed, dashingly drawn scene. In his article on the drawing Benisovich provided the information that the picture mentioned by Lamour as Benard's was once "at Lunéville, near Nancy, before the war of 1914 which so impoverished that region" (Benisovich, p. 58). Yet, despite this and the seemingly irrefutable documentation provided by Lamour's book, some scholars hold to an earlier attribution based on the signature at the lower right: "Chardin."

Federico Bencovich
Ragusa, Dalmatia 1670-1740 Gorizia

Bencovich was probably a fellow student of Giovanni Battista Piazzetta (1682-1754) in the studio of Giuseppe Maria Crespi (1665-1747) in Bologna. Shortly after 1710 he went to Venice. There he worked with Piazzetta; his paintings of these years are often confused with those of his friend. Later his brushwork became more fluid and the paintings more atmospheric. By the 1730s, under the influence of Magnasco, his line had become broken, tense, and dramatic. In Venice he taught Rosalba Carriera (1675-1757) who painted miniatures after his drawings; he also influenced the young Giovanni Battista Tiepolo. Bencovich worked in Vienna (1703) and Milan and in 1733 became court painter to Frederic Karl Schönborn of Bamberg and Wurzburg.

6

Portrait of a Man (ill. p. 58)
Black and white chalk
On the verso: fragment of a male head and two arms
425 x 296 mm. ($16^{11}/_{16}$ x $11^5/_8$ in.)
Exhibitions: San Diego, Fine Arts Gallery, *Baroque Paintings and Drawings*, 1973; Santa Barbara, Art Galleries, *European Drawings*, 1975, No. 6
Literature: Santa Barbara, Art Galleries, University of California, *European Drawings*, 1975, No. 6
Private Collection

In the second decade of the eighteenth century in Venice Bencovich worked closely with Giovanni Battista Piazzetta. Both of them drew the subject of this drawing, a pensive old man with sloping forehead and long beard. Piazzetta painted him twice (illustrated in Rudolfo Pallucchini, *Piazzetta,* Milan, 1956, fig. 3 and Egidio Martini, *La Pittura Veneziana del Settecento,* Venice, 1964, fig. 1; both are noted by Richard Eisele in his entry on Bencovich in Santa Barbara, *European Drawings,* 1975, no. 6). Bencovich also painted this old man in his *Socrates Encouraged to Escape from Prison* in the Bruckenthal Museum, Sibiu (fig. 4), a work which has been dated around 1730 (Pietro Zampetti, *Dal Ricci al Tiepolo,* Venice, 1969, No. 51). The drawing is not, however, a preparatory drawing for the painting, and stylistically it is closer to Bencovich's work of around 1720. In the drawing the seated woman and the studies of hands, feet, and draperies are essentially linear renderings. It is in the subtlety of the modeling of the old man's head that we can sense the influences of Piazzetta, one of Italy's most sensitive draughtsmen in chalk during the eighteenth century.

Johann Georg Bergmüller
Turkheim 1688-Augsburg 1762

A frescoist and painter of altarpieces, Bergmüller studied in Munich with Andréas Wolff (1652-1716), and his style suggests that he may also have studied in Rome with the Baroque classicist Carlo Maratta (1625-1713). In 1712 he settled in Augsburg. In 1730 he became the director of the Academy of Augsburg, the first school of its kind to be established in Southern Germany for the training of artists.

Bergmüller is best known for his ceiling fresco of 1736 in J. M. Fischer's church at Diessen and for his work of 1751 in the abbey at Steingaden. His particular significance, however, was as a teacher, and his solid talent and Italianate training attracted many of the young painters from the Tyrol, Bavaria, Swabia, and Austria who were to shape the art of Central Europe throughout the century. Among them were three other artists represented in the exhibition: J. W. Baumgartner, J. E. Holzer, and Januarius Zick.

7

St. Martin Appealing to the Virgin (ill. p. 55)
Pen, black ink, and watercolor
Signed and dated, bottom left: *Joh. Georg Berkmuller fecit Ano. 1715*
340 x 201 mm. ($13^3/_8$ x $7^7/_8$ in.)
Provenance: C. Rolas du Rosey
Exhibitions: Sacramento, *The German Masters,* 1939, No. 46; University of Kansas, *German and Austrian Prints,* 1956, No. 6; The Baltimore Museum of Art, *Age of Elegance: The Rococo and its Effects,* 1959, No. 260 (entitled *Pleading for the Intercession of the Holy Virgin);* Sarasota, *Central Europe,* 1972, No. 61
Literature: Sacramento, *The German Masters,* 1939, No. 46; University of Kansas, *German and Austrian Prints,* 1956, No. 6; The Baltimore Museum of Art, *Age of Elegance: The Rococo and its Effects,* 1959, No. 260; Sacramento, *Master Drawings,* 1971, p. 148; Sarasota, *Central Europe,* 1972, No. 61
The E. B. Crocker Art Gallery, Sacramento (60)

Bergmüller's earliest altarpieces were produced shortly after he settled in Augsburg. One of these was the *Glorification of St. Martin,* done for the parish church of Merching. It is to this painting that the Crocker drawing and a similar study of 1714 in Nuremberg (illustrated in Monika Heffels, German Nationalmuseum, Nuremberg, *Die deutschen Handzeichnungen,* IV: *Die Handzeichnungen des 18. Jahrhunderts,* Nuremberg, 1969, No. 15) are related. In its verve, freshness, size, and design the Crocker drawing resembles yet another of Bergmüller's early ink and watercolor studies for an altarpiece, *The Assumption of the Virgin* of 1714 in Frankfort am Main (illustrated in Frankfurt am Main, Städelsches Kunstinstitut, *Katalog der deutschen Zeichnungen: Alte Meister,* Munich, 1972, No. 614).

This drawing, like Bergmüller's other early studies,

remains within the academic tradition of the late Roman Baroque. Bergmüller's later work became increasingly more naturalistic and Rococo in its style.

Francesco Galli Bibiena
Bologna 1659-1739 Bologna

Francesco Galli Bibiena belonged to a large and active family of painters. His father, Giovanni Mauro Bibiena, was his first teacher; and his brother, Ferdinando Bibiena (1657-1743), was also a painter. Around 1673 he studied with Lorenzo Pasinelli (1629-1700) and for a short while with Carlo Cignani (1628-1719). In 1679 he painted his first architectural scene for the Palazzo Ducale in Piacenza. In addition to painting, he had an active career as a designer of theater sets, working first in Parma and Rome, and was appointed architect to the Duke of Mantua. He traveled to Naples, Vienna (where he built a theater), London, Verona, and Rome before returning to Bologna in 1726. The next year he became a member of the Accademia Clementina and a few years later its director.

8

Architectural Scene (ill. p. 57)
Pen, brown ink, grey wash, watercolor over graphite
329 x 498 mm. (13 x 19⅝ in.)
Provenance: Zeitlin and Ver Brugge, Los Angeles
Private Collection

In the late seventeenth and early eighteenth centuries there was a passion for the theater. Huge sums of money were spent on lavish productions, particularly for the opera. Francesco Galli Bibiena and his brother were both set designers of distinction, and Francesco was the architect of two theaters, one in Vienna, the other in Verona. That this drawing may be a set design is suggested by the abrupt ending of the balustraded colonade at the right. This open space creates an architecturally illogical plaza in the foreground. It would be suited, however, to a stage set filled with actors or singers such as the three groups of figures in the drawing, drawn by another artist. As the eighteenth-century stage rose rapidly toward the back, the steep perspective used in this drawing would have been an accurate representation of a theater set. Moreover, the elaborate and detailed rendering of the two colonades and the obilisque suggest that this was a working drawing from which these objects would actually have been built for the production. The more lightly drawn and water-colored gardens, the wing of the palace, and the ornate palace in the background might have been the basis for a painted backdrop.

Giuseppe Bernardino Bison
Palmanova 1762-1844 Milan

Bison studied in Venice with Anton Maria Zanetti (1706-

1775), Constantino Cedini (1741-1811), and with the architectural view painter Antonio Mauro (fl. 1780-1795). He worked as a designer of ornaments, altarpieces, and frescoes in Padua, Treviso, Udine, Zara, and Trieste. Above all, he was a very prolific draughtsman. The frescoes he produced at the Palazzo Manzoni in Padua from 1787 to 1790 show the strong influence of G. B. Tiepolo while his later works, in Trieste and Milan, are more Neo-Classical in style. In 1831 he moved to Milan and between 1834 and 1838 was active in Florence and Rome.

9

Warrior Astride a Centaur (ill. p. 107)
Pen, brown ink, and wash
Signed, lower left: *Bison*
241 x 178 mm. (9½ x 7 in.)
Exhibitions: Santa Cruz, University of California, 1968; Claremont, Harvey Mudd College, *16th Century Drawings to 20th Century Drawings,* 1969
Literature: Los Angeles, *Drawings,* 1970
Los Angeles County Museum of Art, Gift of Mr. and Mrs. Lorser Feitelson (67.5)

The subject of *Warrior Astride a Centaur* comes from antiquity where the centaur — half man and half horse — symbolized the bestial forces in man. But, unlike that of his contemporaries, Bison's Neo-Classicism is neither archaeological nor intellectual. Rather, like his Venetian predecessor Giovanni Battista Tiepolo, he was inspired by the recreations of the antique that occurred in sixteenth-century Venetian painting. In both spirit and style Bison's draughtsmanship is closer to Tiepolo's than to a Neo-Classicist's like David. The line in the *Warrior Astride a Centaur* is searching, lively, and apparently spontaneous, and the lights and shades of the washes create a vibrant rhythm. Both are the product of Bison's essentially sensual and emotional temperament.

It is nearly impossible to establish a chronology for Bison's drawings (Aldo Ricci, *Cento disegni del Bison,* Udine, Loggia del Lionello, 1962, p. 16). However, the strong Venetian influence on this work would place it around 1800 (see Ricci., Pls. 38 and 42).

François Boucher
Paris 1703-1770 Paris

The great decorative painter of the High Rococo, François Boucher, began his artistic career as the student of François Lemoine. He soon left his first teacher to study with the elder Cars, and as early as 1722 he may have begun to engrave the works of Watteau. He made a trip to Italy in the late 1720s and was elected to the Academy in 1734 as a history painter. His reception piece was the painting *Rinaldo and Armida* (now in the Louvre).

The works he first exhibited at the Salon, in 1737, were pastoral scenes in the Flemish tradition. These were followed by a succession of portraits, landscapes, and mythological paintings, among them *Cupid Wounding Psyche* of 1741 (in the Los Angeles County Museum of Art). Under the patronage of Madame de Pompadour, whose portrait Boucher painted on several occasions, his rise to success was rapid. In 1765 he was appointed first painter to Louis XV and Director of the Academy. However, by the time of his death in 1770, public interest had turned from Boucher's voluptuous fantasies of the lives of the gods to moral and sentimental scenes of domesic life.

10

Head of a Roman Soldier (ill. p. 66)
Red, black, and white chalk on buff paper
Glomy stamp (Lugt 1085), bottom right, in 18th-century paper mount
195 x 180 mm. (7⁵⁄₈ x 7 in.)
Provenance: William Bourn: Filoli; Mrs. Osgood Hooker, Sr.; Osgood Hooker
Exhibitions: Slatkin, Washington, *François Boucher,* 1973-1974, No. 18
Literature: Slatkin, Washington, *François Boucher,* 1973, p. 24
Fine Arts Museums of San Francisco, Gift of Mr. Osgood Hooker (1959.117)

Unlike his contemporary G. B. Tiepolo, Boucher was partial to chalk as a drawing medium because it could achieve subtle modulations of color and texture. Like Watteau, he often used red, black, and white chalk — a technique known as *"trois crayons."* It was in this manner that he was able to capture with remarkable economy the glint of armor and the vitality of the soldier. This drawing was perhaps one of a series of early drawings based on the Column of Trajan and engraved by Hutin with the title *Recueil de différents têtes tirés de la colonne Trajane.* It has thus been dated in the 1730s but may be as late as 1750.

11

Design for an Overdoor Decoration (ill. p. 68)
Black chalk on cream paper
Inscribed, bottom right on mount: *f. Boucher*
153 x 217 mm. (6 x 8¹⁄₂ in.)
Provenance: Edwin Bryant Crocker
Exhibitions: Sacramento, Crocker Art Gallery, *Drawings of the Masters,* 1959, No. 1; Slatkin, Washington, *François Boucher,* 1973-1974, No. 15
Literature: Rosenberg, *Master Drawings,* 1970, p. 39, No. 1; Sacramento, *Master Drawings,* 1971, p. 148 (as *Group of Angels and Cherubs Holding Picture*); Slatkin, Washington, *François Boucher,* 1973, p. 21
The E. B. Crocker Art Gallery, Sacramento (440)

Boucher very often used black chalk against a bistre background for his drawings. This sheet, with its angels and cherubs bearing a portrait, was probably intended as a design for the decoration of an elaborate interior. Its purpose may have been to commemorate either the owner or a notable ancestor. Boucher used Rococo ornaments of this kind in his decorative schemes for the Salle du Conseil at Fontainebleau, the royal apartments at Versailles, and the various chateaux of Madame de Pompadour which he was commissioned to embellish along with other painters of his time.

12

Landscape with a Boy and a Dog (ill. p. 69)
Black and white chalk
255 x 349 mm. (10 x 13¹¹⁄₁₆ in.)
Provenance: Charles E. Slatkin Gallery, New York
Exhibitions: New York, Slatkin Gallery, *François Boucher 1703-1770 Prints and Drawings,* 1957, No. 27; Los Angeles, University of California, *French Masters Rococo to Romanticism,* 1961, No. 28; Santa Barbara, *Drawings,* 1970, No. 27
Literature: *François Boucher 1703-1770 Prints and Drawings,* ed. Regina Shoolman, New York, 1957, No. 27, Pl. XXV; *French Masters Rococo to Romanticism,* ed. Jerrold Ziff, Los Angeles, 1961, No. 28; Santa Barbara, *Drawings,* 1970, No. 27 (ill.)
Santa Barbara Museum of Art, Gift of Mr. Wright Ludington (57.8.1)

Despite the fact that they are not idealized visions, Boucher's pastoral scenes suggest a relief from the frustrations of urban life. Not only in his mythological paintings but in his landscapes as well, Boucher was influenced by the Flemish tradition. This is particularly evident in the manner in which his rustic settings are animated by the accidental spill of the forms of nature.

Giuseppe Cades
Rome 1750-1799 Rome

Cades, the son of a Frenchman, was born in Rome. He was a pupil of Domenico Corvi (1721-1803). The year 1766 was a dramatic one in his life; his master expelled him because of his independence, and he won first prize at the Accademia di San Lucca. Twenty years later, in 1786, he became a member of the same Academy. Cades made copies of old masters in Rome and Florence, chiefly for English and German patrons. Among his many drawings imitating old masters was a large "Raphael" bought by the director of the Dresden drawing cabinet. In the 1780s and 1790s when there was a fashion for costume pieces, his work was especially sought after. In these decades he probably sold more drawings than any other living Roman artist.

Luncheon on the Terrace (ill. p. 108)
Pen, brown ink, and wash over black chalk
462 x 250 mm. (18 x 9¾ in.)
Exhibitions: Santa Barbara, *Drawings,* 1970, No. 75
Literature: Santa Barbara, *Drawings,* 1970, No. 75 (ill.)
Santa Barbara Museum of Art (62.20)

Cades made drawings for every conceivable purpose. He was best known for his imitations of old masters and for his drawings of historical, mythological, and religious scenes. He also drew genre scenes either as illustrations for works by contemporary authors or as autonomous subjects. In this genre scene men and women are seated and standing around a table, on a terrace. A servant boy carrying a platter descends the staircase in the foreground. Above is a column partially draped by a curtain below which are shelves supporting dishes. In the background at the left is a hilly landscape.

Many of these genre drawings echo the composition of religious paintings. The arch format of the *Luncheon on the Terrace* suggests an altarpiece, and the column and drapery are accoutrements which appear in religious paintings as early as Titian's. The servant boy is reminiscent of a figure from a *Marriage at Canna* by Veronese, or Giovanni Tiepolo's *Banquet of Antony and Cleopatra* in the Palazzo Labia (fig. 9). Similarly, the composition in Cades' *Domestic Scene* in the Museo Nacional de Arte Antiga (illustrated in Anthony Clark, "An Introduction to the Drawings of Giuseppe Cades," *Master Drawings,* II [1964], Pl. 14b) reminds one of a *Birth of the Virgin* in which children are being bathed at the left and the exhausted mother is being fed at the right. (See Cades' own version of the scene in the collection of Mr. and Mrs. Edward A. Maser, Chicago, Clark, Pl. 9.)

Jacob Cats
Altona 1741-1799 Amsterdam

Cats was born in Altona, Germany, but at an early age moved to Amsterdam with his bookdealer father. He worked first for a cloth merchant and then for a bookbinder. For three and a half years he studied with Pieter Louw (c. 1720-c.1800). After having worked in a wallpaper factory for a time, he established one of his own which he eventually sold in order to devote his time fully to drawing.

Cats seems to have been a draughtsman exclusively, and no paintings or decorations of his survive. Although to meet the demands of collectors he made copies after Rembrandt and Bartholomeus van der Helst, the majority of his drawings are of topographical and landscape scenes. These possess a freshness of interpretation unusual to Dutch eighteenth-century art. Many of these scenes were reputed to have been composed from memory.

Jacob Cats was not only the most outstanding draughtsman to emerge from Holland during the second half of the eighteenth century but was a master at capturing atmosphere and light as well.

Landscape (ill. p. 98)
Pen, black and brown ink, grey wash
Inscribed in an eighteenth-century hand on the verso:
N. 524 J. Cats inv et fe. 1788
155 mm. (circular) (6⅛ in.)
Provenance: Zeitlin and Verbrugge, Los Angeles
Mr. Rudolph Baumfeld

The composition of this landscape, which is skillfully arranged to fit the round format of the drawing, may have been made as a model for an engraving. The hilly landscape is hardly typical of Holland and, though reminiscent of German landscapes, was most likely a product of Cats' own invention. Nevertheless, it reveals his acute observation of nature and his ability to create a sense of atmosphere. Areas of the paper left white seem saturated with sunlight while grey washes suggest shadows, and the brown ink, primarily on the foliage, captures the excitement of the play of light on the landscape.

Daniel Chodowiecki
Danzig 1726-Berlin 1801

Chodowiecki, who was of French and Polish descent, was a draughtsman and engraver of extraordinary productivity and talent. He took up engraving in Berlin in his thirties after he had established himself as a miniaturist specializing in portraits on enamel. An early print, *The Game of Dice,* won him the regard of the Berlin Academy in 1756, and he was commissioned to illustrate the first of many almanacs. These he engraved with humor and skill throughout his life.

It was in 1767, however, that Chodowiecki became famous with the publication of a print after his own painting of the *Farewell of Calas.* In the manner of Jean Baptiste Greuze, the print appealed to the public's taste for emotional melodrama.

A fashionable book illustrator, Chodowiecki had a distinctive gift for satirical comment. This is particularly evident in the vignettes he engraved for almanacs and calendars during the last quarter of the century. Chodowiecki's moralizing characterizations, drawn with a lively and entertaining realism and a delicacy and charm of line, touched upon subjects of middle class concern. Not surprisingly, Chodowiecki was frequently compared to William Hogarth, who was much admired in Germany at the time. But Chodowiecki's satirizing of the frivolity of German life was not intended to have the ferocity of Hogarth's prints.

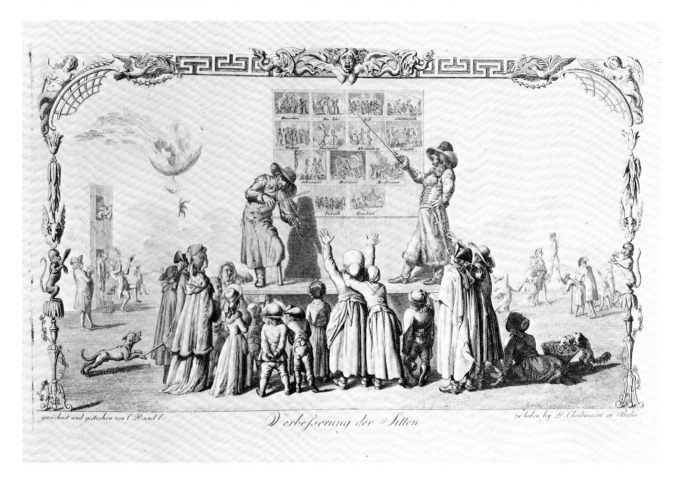

Verbesserung der Sitten

5 *Die Verbesserung der Sitten,* 1787, engraving, C. D. and E.,
British Museum, London

15

The Improvement of Morals (*ill. p. 96*)
Red chalk, pen over graphite
202 x 336 mm. (8 x 13¼ in.)
Exhibitions: Berkeley, *Master Drawings,* 1968, No. 23;
Sacramento, *Master Drawings,* 1971, No. 85
Literature: Berkeley, *Master Drawings,* 1968, No. 23 (ill.)
Sacramento, *Master Drawings,* 1971, No. 85 (ill.); David
Kunzle, *History of the Comic Strip,* Vol. I, Berkeley, 1973,
p. 401
The E. B. Crocker Art Gallery, Sacramento (72)

The finished study for Chodowiecki's engraving of 1787,
Die Verbesserung der Sitten (fig. 5), is not an illustration
for an almanac or a calendar. Rather, it is a satire on a
journalistic venture by a fellow engraver named Merino.
(The artist mentions the subject in a letter of March 3, 1787,
quoted in G. Steinbrucker, ed., *Briefe Daniel Chodowieckis
an Anton Graff,* Berlin and Leipzig, 1921.) Merino had
envisioned publishing weekly a series of remarkable events
drawn from the everyday lives of his fellow Berliners. But
after thirteen sketches he abandoned the project. Chodow-
iecki, who obviously thought the venture was foolish and

opportunistic, ridiculed Merino throughout this drawing.
In the center of the drawing is a board on which the
"remarkable" events are represented. Included are Christ-
mas, New Year, Sledding, Marriage, Discord, Divorce, the
Concert, Drama, Robbery, Arson, the Picnic, and Sickness.
Pointing to the sketch of the Ball on the board is a teacher-
barker wearing a sword. This image elicits the excited
gesture of the woman in the center of the crowd. At the
right in the background are scenes of folly: a woman
riding astride a crawling man, a young officer with a rich,
old, ugly woman, and two acrobats. Depicted at the right is
an artist sketching upon a pad supported by a bent-over
man. At the left side of the drawing is another artist,
overly-well fed, who calmly sketches a man hanging in the
doorway. Another man looks at a drawing in his hand and
swallows fire. In the background a duel is in progress;
above, a man falls from a balloon in flames. Even the border
includes satirical jabs. There are the figures of the two
apes, the harpies with beatific smiles at the corners, and
the grimacing harpy in the center. Chodowiecki makes it
plain that the foibles of mankind are worsened, not
improved, by stupid publicity

Charles-Nicolas Cochin
Paris 1715-1790 Paris

Charles-Nicolas Cochin, engraver, draughtsman, writer, and *bon vivant,* had an enormous influence at the French court. Consultant to Denis Diderot, friend of François Boucher, he was officially curator of the king's drawing collection with a residence in the Louvre. He was also principal advisor to the director of fine arts, the Marquis de Marigny, brother of Madame de Pompadour. Cochin accompanied the Marquis on a trip to Italy in 1750. On the death of Bernard François Lepicié in 1754, he was named historian and secretary of the French Academy.

Cochin was born to a family of artists and engravers. His earliest study was with his father and mother, Charles-Nicolas Cochin (1688-1754) and Louise Madeleine Horthemels (1686-1767). He later worked with the painter Jean Restout (1692-1768). Cochin's first popular successes were his designs and engravings for court celebrations. Subsequently he designed numerous book illustrations and produced delightful series of portraits of French celebrities. An amusing conversationalist and an outspoken critic, Cochin had a reputation for liking good jokes and lively supper parties. He was an intimate of Madame Geoffrin and a frequent guest at her salon.

16

Portrait of François-Emmanuel Pommyer, Abbé de Bonneval *(ill. p. 84)*
Black chalk
Titled, inscribed and dated under drawing, left: *Dessiné par C-N Cochin a Gandelu;* right: *le 29 mars 1771;* Centered below is the title: *Le Paysan de Gandelu,* and *Vertueux, plein de sentiment, patron de l'innocence: L'honneur est son seul élément, il est sa recompense*
235 x 187 mm. (9³/₁₆ x 7³/₈ in.; sheet of drawing: 305 x 260 mm. [11¹⁵/₁₆ x 10³/₁₆ in.]; Contemporary French mount, lined, and with the artist's inscription)
Provenance: Yves-Joseph-Charles Pommyer de Rougement to the Baron de Rosée in whose family the drawing remained for four generations until dispersed in 1966; William H. Schab, New York
Literature: Robert Portalis, *Les dessinateurs d' illustrations au dix-huitième siècle,* Paris, 1877, I, p. 100; William H. Schab, *Fifty Master Drawings,* New York, undated, No. 29a
Stanford University Museum of Art, Palo Alto, Mortimer C. Leventritt Fund (72.48)

Cochin's portrait of his intimate friend, François-Emmanuel Pommyer, sketched during his annual visit to his friend's home, was one of a group of four drawings done at Gandelu in the early seventies. In 1771, the same year as the Stanford drawing, Cochin also sketched the buildings at Gandelu. In the following year he drew Yves-Joseph Charles Pommyer de Rougement and a second male portrait now in a private collection in Bremen. (These are illustrated in the Schab catalogue, Nos. 29b-c, and in *Zeichnungen Alter Meister aus deutschem Privatbesitz,* Kunsthalle, Bremen, 1966, No. 167.) His portrait of François-Emmanuel Pommyer was engraved by Demarteau the elder.

Pommyer was also the subject of a profile bust portrait in medallion by Cochin, one of a series of more than two hundred and sixty portraits of prominent Frenchmen which he drew but only rarely engraved. The Pommyer medallion, entitled *Conseiller en la Grande Chambre du Parlement,* was engraved by Saint Aubin (Illustrated in Paul Prouté, *Catalogue "Cochin",* Paris, 1962, No. 116).

Antoine Coypel
Paris 1661-1722 Paris

Antoine Coypel was the son of the painter Nöel Coypel (1628-1707) and the father of the painter Charles-Antoine Coypel (1694-1752). He studied with his father, whom he accompanied to Rome in 1672, remaining there until 1676. As a twelve-year-old in Rome, he won a prize at the Academy of Saint Luke. In 1681 he was admitted to the French Academy and that same year became *premier peintre* to the Duc d'Orleans. He became a professor at the Académie des Beaux-Arts in 1692 and its director in 1714. A year later he became *premier peintre* to the king and in 1717 was ennobled. A friend of the leading writers — Racine, Boileau, La Fontaine, and Roger de Piles — Coypel himself wrote a treatise on painting between 1708 and 1714: *Epitre à mon fils sur la peinture.* Coypel had many large, decorative commissions including numerous cartoons for tapestries and paintings at Choisy, the Palais Royal, Versailles, Meudon, and the Hotel Lambert. Historically, his painting forms the bridge between Charles Le Brun and Antoine Watteau.

17

Two Female Figures, Draped *(ill. p. 49)*
Red chalk
157 x 88 mm. (6¹/₈ x 3¹/₂ in.)
Provenance: Buentabouret
The Norton Simon Foundation, Los Angeles

This study of two women is probably a preparatory drawing for a painting. The ample drapery and the pulled-back hair style indicate that its subject would have come from antiquity. The supple, painterly use of chalk is similar to that in Coypel's early drawings which are noteworthy for their elegance and looseness of treatment.

Jacques-Louis David
Paris 1748-Brussels 1825

Jacques-Louis David, the great painter whose work dominated the art of the French Revolution and galvanized the artistic current of the next century, began his awesome career as a boy who loved to draw. Following the advice of François Boucher, a relative of his mother, David became a student of Joseph Marie Vien. (1716-1809). He competed for the *Prix de Rome* for several years, finally winning it in 1774 with his painting *Antiochus and Stratonice.*

David spent five important years in Rome from 1775 to 1780. There he discovered the monuments of classical antiquity, the work of earlier Baroque painters, and, finally, his own style. A year after his return to Paris his success was assured when he exhibited the following works at the Salon of 1781: *Belisarius Receiving Alms, St. Roch Interceding with the Virgin, A Woman Suckling her Child, Count Potocki,* and the *Funeral of Patroclus.*

Returning briefly to Rome, David completed and exhibited his famous painting, the *Oath of the Horatii* (1785), a proclamation of the moral heroism of the Neo-Classical. A supporter of the Revolution, David's rebelliousness was directed at the Royal Academy. His portrait of 1800, *Napoleon Crossing the Alps,* points the way to the Romanticism of the nineteenth century, which was carried on by many of the pupils he influenced with his undoctrinaire attitudes and versatility. David lived in exile in Brussels from 1816 until his death in 1825.

18

Funeral of a Warrior (ill. pp. 90, 91)
Pen and black ink over black chalk with white gouache highlights on blue-grey paper
Verso: Pen inscription in an old hand: *Funéraille de Patrocle/L. David fécit Roma 1778/du cabinet de Pécoul son beau-père/ n. 294;* and notes in black chalk which include the name Weigel (1812-1881, Lugt 2554) from whom Crocker probably bought the drawing
260 x 1530 mm. (10⁷/₁₆ x 60 in.)
Exhibitions: Sacramento, *Master Drawings,* 1971, No. 93; Rosenberg, Ontario, *French Master Drawings,* 1972, No. 39; London, The Royal Academy and the Victoria and Albert Museum, *The Age of Neo-Classicism,* 1972, No. 550

Literature: Rosenberg, *Master Drawings,* 1970, No. 20, Pl. 38; Steven Nash, Letter to *Master Drawings,* VIII, No. 3 (Autumn 1970), pp. 295-296; Sacramento, *Master Drawings, 1971,* No. 93 (ill.); Rosenberg, Ontario, *French Master Drawings,* 1972, No. 39; London, The Royal Academy and the Victoria and Albert Museum, *The Age of Neo-Classicism,* 1972, No. 550; E. B. Crocker Art Gallery, *Classical Narratives in Master Drawings,* ed. Seymour Howard, Sac-

ramento, 1972, pp. 26-27; Jacques de Caso, "Jacques-Louis David and the Style 'All' antica," *The Burlington Magazine,* CXIV, No. 835 (October 1972), pp. 686-690; Christopher Sells, Letter to *The Burlington Magazine,* CXV (February 1973), p. 122; Arlette Serullaz, Letter to *The Burlington Magazine,* CXV (May 1973), p. 330; Robert Rosenblum, "David's 'Funeral of Patroclus,' " *The Burlington Magazine,* CXV (September 1973), pp. 567-576
The E. B. Crocker Art Gallery, Sacramento (408)

David's epic drawing, *Funeral of a Warrior,* is an outstanding testament of his awakening interest in the antique manner. He drew it at about the same time (1778-1780) that he painted the recently discovered *Funeral of Patroclus,* acquired in 1973 by the National Gallery of Ireland. (The painting, recorded in the 1781 Salon catalogue, disappeared for nearly two centuries.) Comparing the two works, Robert Rosenblum writes: "With its grave tempo and slowly unwinding isocephalic procession of solemn figures who cling, in profile and frontal dispositions, to the planarity of a frieze, this version of the *Funeral of Patroclus* virtually provides an emotional and visual antithesis to the vital Rococo premises still so discernible . . . in the Dublin painting" (Rosenblum, p. 571).

The object of considerable interest since its discovery by Pierre Rosenberg in 1970, the drawing illustrates Homer's moving account of the mourning for and burial of Patroclus in Book XXIII of the *Iliad.* Its central focus is the dead warrior with the armed Achilles at his head and either his old praeceptor Phoenix, or Nestor holding his arm. At the left are the Dacian prisoners and Briseis and her maids bearing the urn. At the right are priests preparing the sacrifice.

Two other David drawings of the *Funeral of Patroclus* are in the Musée Eugène Boudin, Honfleur, and in the Louvre.

School of David

19

Death of Camilla (ill. p. 92)
Black ink and graphite
101 x 113 mm. (3¹⁵/₁₆ x 4¹⁵/₁₆ in.)
University Art Museum, University of California, Berkeley (1968. 89a)

The Roman story of Camilla's death at the hands of her brother Horatius was one of a number of moral paradigms portrayed in Neo-Classical art. Stern antitheses to the frivolous mythologies of the Rococo, these legends were chosen to illustrate virtuous conduct and dedication to principles of justice.

6 Christian Wilhelm Ernst Dietrich, *Two Gorgon Heads*, pen and brown ink, 44 x 70 mm., The E. B. Crocker Art Gallery, Sacramento (991)

Camilla was killed because she mourned her lover, one of the enemy vanquished by the Horatii. The story of her death was recounted in Charles Rollin's *Histoire romaine* (1738-1748), a popular source of many such legends. Jacques-Louis David based a series of studies for the *Oath of the Horatii* upon it (illustrated in Arlette Calvet, "Unpublished Studies for *The Oath of the Horatii* by Jacques-Louis David," *Master Drawings,* VI [1968], Pl. 23). The Berkeley drawing, however, does not relate very closely to David's compositional solution nor does its curvilinear stroke seem characteristic of his hand.

As the death of Camilla was the subject of the *Prix de Rome* competition in 1785, the drawing may have been a preliminary sketch for a composition by one of David's students. However, the impersonal stylistic conventions of Neo-Classical drawings and the wide-ranging technical variety of the period make it difficult to establish the identity of the artist conclusively.

Christian Wilhelm Ernst Dietrich
Weimar 1712-1774 Dresden

Christian Dietrich's father, who was court painter at Weimar, taught his talented son to draw before sending him to Dresden in 1724 for further training with the land-scape painter Thiele Johann Alexander (1685-1752). Recognizing his student as an artistic *wunderkind,* Thiele presented him to Augustus the Strong of Saxony who became Dietrich's benefactor. Under his patronage, Dietrich traveled to Holland, Venice, and Rome during the 1730s. He returned to Dresden in 1741 with his friend Anton Raphael Mengs. There he became court painter, director of the Picture Gallery, and, in 1763, professor at the Academy. He also administered the art school of the porcelain factory at Meissen.

Dietrich had a ready facility for absorbing the styles of earlier masters. Winckelman called him the Raphael of landscape, and he did a number of paintings in the manner of Rembrandt. His drawings show a similar versatility, ranging from the rhythmic liveliness of the Rococo to the taut severity of the emerging Neo-Classical style.

20

Head of a Woman (ill. p. 82)
Pen and brown ink
58 x 70 mm. (2¼ x 2¾ in.)
Literature: Sacramento, *Master Drawings*, p. 150
The E. B. Crocker Art Gallery, Sacramento (993)

This tiny yet powerful head of a woman is a striking pre-cursor of the Neo-Classical linearism which later emerged in England in the work of William Blake and John Flaxman. It is one of seven small drawings by Christian Dietrich at The E. B. Crocker Art Gallery (another is fig. 6). Many came from the collection of the art dealer Rudolph Weigel in Leipzig, the major source of the German drawings at the Crocker. The Crocker also has two large drawings by Dietrich, one of which was published by Seymour Howard in the catalogue *Classical Narratives* (1972, No. 32) and is identified as *Hermes Stalking Argus.*

Richard Earlom
London 1742/43-1822 London

It is said that Richard Earlom became interested in art when he saw the paintings of G. B. Cipriani (1727-1785) which decorated the coach of the Lord Mayor of London. He became a student of Cipriani and in 1757 won a prize at the London Society of Artists. He quickly became a master of mezzotint engraving and was known for the fineness of his mezzotint grounds. Working steadily for the publisher J. Boydell, he produced more than five hundred prints in his lifetime. Among his major works were in 1774-1777 the facsimile version of Claude Lorrain's *Liber Veritatis* in the Duke of Devonshire's collection and, in 1789, forty-three of the fifty folios of the *Collection of Prints after Sketches and Drawings of the late Celebrated G. B. Cipriani.*

21

Study of a Seated Male Nude Grasping a Staff (ill. p. 105)
Black and white chalk on pale brown prepared paper
368 x 262 mm. (14¼ x 10¼ in.)
Provenance: Thomas Cornell, Brunswick, Maine
Private Collection

Richard Earlom, perhaps the greatest mezzotint artist of the eighteenth century, was also a fine draughtsman. This study of a seated male nude grasping a staff is a work of the artist's maturity, drawn around 1785 to 1790. In it

Earlom's interest focused on the over-development and taut musculature of the man's right arm. The drawing has the added interest of the contrast between the very subtly modeled head of the full figure and the rapid, linear quality of the two sketches of the man's head at the right. The Fine Arts Museums of San Francisco also has a large male nude study by Earlom (fig. 7).

Jean-Honoré Fragonard
Grasse 1732-1806 Paris

Having settled in Paris by 1742, Fragonard had a brief stay in the studio of Jean-Baptiste Chardin (1699-1779) before becoming a pupil of François Boucher. In 1752 he won the *Prix de Rome* and in 1755 was admitted to the Ecole Royale des Elèves Protégés. In the following year he went to the French Academy in Rome and remained in Italy until 1761. In Rome he was a close friend of Hubert Robert and the Abbé de Saint-Nom. In 1765 he became a member of the Academy, and his reception piece, *Coreus Sacrificing himself to Save Callirrhoe,* was purchased by Louis XV for the tapestry workshop of Gobelins. A year later, with his painting *The Swing,* his true originality as a painter of blithe, pastoral, erotic subjects became evident. Through the print made after it, *The Swing* enjoyed enormous popularity. In 1771 Fragonard was commissioned by Madame du Barry, favorite of the king, to paint the series *The Progress of Love* (now in The Frick Collection, New York) for her chateau at Louveciennes. In 1773 Fragonard returned to Italy in the company of the financier Bergeret. After the Revolution of 1789 he was made a conservator at the National Museum by its director, Jacques-Louis David. Under the Directory, however, he was dismissed from public office, and he died in poverty.

22

Adoration of the Magi (after Veronese) *(ill. p. 79)*
Black chalk
Inscribed, lower right: *Paul Veronese, Eglise de San Nicolette, Venise*
210 x 293 mm. (8^1/$_4$ x 11^7/$_{16}$ in.)
Provenance: Abbé Jean Claude Richard de Saint-Nom; Comtesse de Bearn-Behague, Paris; Hon. Irving Laughlin, Washington, D.C.; Mrs. Hubert Chandler, Genese, New York; Maggs Brothers, Ltd., London; Fl. Tulkens, Brussels
Exhibitions: Paris, Galerie Beauvau, *Fragonard et les Grands Maitres Italiens,* 1960, No. 48
Literature: Sotheby & Co., *Old Master Drawings,* London, June 10, 1959, No. 17; *Catalogue Raisonné de Cent Quarante et un Dessins de Fragonard d'apres Fresques et Tableaux en Italie, 1760-1761* (Collection Laughlin) privately printed, n.d.; Galerie Beauvau, *Fragonard,* Paris, 1960, No. 48, p. 47; Ananoff, *Fragonard,* III, No. 1806
Engravings: *Fragments,* Pl. 2, 5th suite; "Griffonis," p. 130
The Norton Simon Foundation, Los Angeles

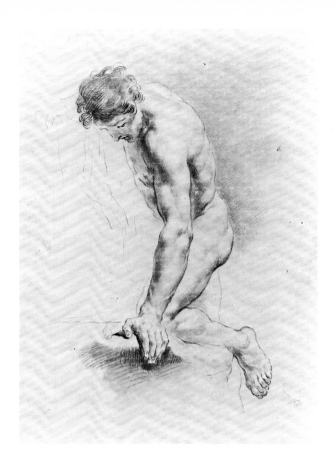

7 Richard Earlom, *Academic Study of a Male Nude,* sanguine, 477 x 354 mm., Fine Arts Museums of San Francisco, Achenbach Foundation for Graphic Arts (69.30.59)

In 1760 Fragonard met the Abbé de Saint-Nom through their mutual friend Hubert Robert. The Abbé was a wealthy patron and a draughtsman and engraver. In early 1761 he sent Fragonard to Naples to draw works of art by Neapolitan painters — Ribera, Calabrese, and especially Solimena. In the beginning of April 1761 the two visited Bologna and Venice on their return trip to Paris. The Abbé collected Fragonard's copies of Italian paintings and wrote descriptive annotations for each. 139 of these copies are now in the sketchbook in the collection of The Norton Simon Foundation. Between 1770 and 1774 the Abbé de Saint-Nom made aquatints after 148 of the drawings. These were published as *Fragments choisis dans les Peintures et les Tableaux les plus interessants dans Pálais et des Eglises de l'Italie.* The Abbé also owned 125 etchings of these drawings by Fragonard which the artist had retouched in chalk. These form the "Griffonis" of 1790 in the Bibliothèque Nationale, Paris.

When Fragonard left for Italy in 1756, his teacher, François Boucher, is said to have advised him that copying Michelangelo and Raphael would be destructive to him. Fragonard seems to have accepted Boucher's advice and to have shared his sensibility. There are no copies after

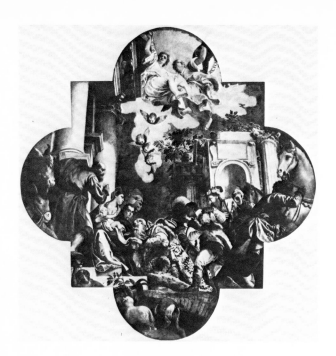

8 Paolo Veronese, *Adoration of the Magi,* Cappella del Rosario, Saints Giovanni and Paolo, Venice

Michelangelo, and the most copied artists are Solimena, Giordano, the Carracci, Tintoretto, Veronese, and Tiepolo. In the Simon sketchbook there are eleven copies of paintings by Veronese including *The Adoration of the Magi* (fig. 8). In 1761 this painting was in the Church of San Nicolo dei Frari, and now it is in the Rosary Chapel of Saints Giovanni and Paolo.

Unlike Guardi (Cat. 32.) in his copy of Veronese's *Christ and the Centurion* (fig. 13), Fragonard exchanged the essentially vertical format of Veronese's painting for a horizontal format. Moreover, Fragonard reduced the architecture and lowered the position of the angels in the sky. He also changed the proportions of the figures, particularly those of Saint Joseph and the Virgin, making them less elongated than they are in the painting. Fragonard's interest was directed at compositional considerations, the flow from figure to figure, and the elegance of the individual poses. However, he was primarily concerned with the overall pattern created by the lighting whose flickering rhythm reinforces the refinement of the composition. Fragonard's shading consists of parallel strokes of the chalk, all slanting in the same direction and made after the outlines of the figures.

23

Banquet of Antony and Cleopatra (after G. B. Tiepolo)
(ill. p. 77)
Black chalk
Inscribed, lower left: *Tiepolo Palazzo Labbia Venise*

283 x 209 mm. (11$^1/_8$ x 8$^1/_4$ in.)
Provenance: Abbé Jean Claude Richard de Saint-Nom; Comtesse de Bearn-Behague, Paris; Hon. Irving Laughlin, Washington, D.C.; Mrs. Hubert Chandler, Genese, New York; Maggs Brothers, Ltd., London; Fl. Tulkens, Brussels
Exhibitions: Paris, Galerie Beauvau, "Fragonard et les Grands Maitres Italiens," 1960, No. 37
Literature: *Catalogue Raisonné de Cent Quarante et un Dessins de Fragonard d'apres Fresques et Tableaux en Italie, 1760-1761* (Collection Laughlin) privately printed, n.d.; Galerie Beauvau, *Fragonard,* Paris, 1960, No. 37, p. 42; Ananoff, *Fragonard,* II, 1963, No. 1108, p. 190; Michael Levey, *Tiepolo: Banquet of Cleopatra,* Newcastle-upon-Tyne, 1965, unpaginated; Everett Fahy, "Tiepolo's Meeting of Antony and Cleopatra," *Burlington Magazine,* 113 (1971) p. 737
Engravings: Engraved by Fragonard, "Fragonard aqua-fortiste"; *Fragments,* Pl. 23, 5th suite; "Griffonis," Pl. 9, p. 134, counter-proof
The Norton Simon Foundation, Los Angeles

When Fragonard visited Venice in 1761, Giovanni Battista Tiepolo was in Spain working for the Spanish royal family. Between 1745 and 1750 the Italian artist had executed one of his major full-scale decorative commissions in the main salon of the Palazzo Labia in Venice. Set in the intricate painted architecture of Girolamo Mengozzi are the frescoes on the side walls, *The Meeting of Antony and Cleopatra,* and *The Banquet of Antony and Cleopatra,* (fig. 9). It has been convincingly argued that Fragonard's copy of *The Meeting of Antony and Cleopatra,* which is also in the Simon sketchbook, was made not after the fresco itself but after a smaller sketch of the same theme (Everett Fahy, "Tiepolo's *Meeting of Antony and Cleopatra,*" *Burlington Magazine,* 113 [1971], pp. 737-738). In the case of *The Banquet of Antony and Cleopatra,* however, the inclusion in the drawing of part of the ceiling fresco *Time and Beauty* argues for a direct knowledge of the fresco.

The Tiepolo *Banquet* shows Cleopatra holding up her pearl in one hand and in the other raising a cup of vinegar. Fragonard's copy of the composition is totally faithful except for the omission of two spears. He also captured with great accuracy the flickering pattern of lights and shades which helps to create the lightness and vivacity of Tiepolo's painting. The major difference between the drawing and the fresco is that Fragonard has reduced the shadow falling on the seated foreground figure at the left. In the fresco the figure is fully shadowed by the painted architecture at the left. The omission creates a more balanced, yet still lively distribution of lights and shadows.

24

An Italian Park *(ill. p. 80)*
Brown wash over black chalk
Signed and dated on the stella, lower right: *frago 1786*

238 x 380 mm. (9½ x 14½ in.)
Exhibitions: Berkeley, *Master Drawings,* 1968, No. 5;
Sacramento, *Master Drawings,* 1971, No. 88
Literature: Ananoff, *Fragonard,* II, 1963, No. 947, p. 138;
Berkeley, *Master Drawings,* 1968 (ill.); Rosenberg, *Master Drawings,* 1970, No. 16, Pl. 34; Sacramento, *Master Drawings,* 1971, No. 88 (ill.)
The E. B. Crocker Art Gallery, Sacramento (88)

Fragonard made a drawing from life of *An Italian Park* during his second visit to Italy in 1774 (Ananoff, *Fragonard,* II, No. 946). Twelve years later in France he drew a second version of the same subject which is now in The E. B. Crocker Art Gallery. The setting in both versions is the same park in a cemetery. The scene is dominated by large trees at the right and buildings on a hill at the left. Funeral monuments, busts, and fallen columns indicate the Roman origin of the now decayed cemetery. The only differences between the two drawings is the addition in the later version of the central figure of a seated man wearing a large hat and the signature and date on the fallen stella at the right. Although not drawn from life, the Crocker drawing has a freshness of feeling and execution. The wash seems to dissolve the materiality of the objects and foliage into flickering forms, imbuing the landscape with a vivacious and agitated rhythm.

Thomas Gainsborough
Sudbury 1727-1788 London

Thomas Gainsborough, who was born in Suffolk, achieved his greatest worldly success as a portrait painter in London, but his deepest personal gratification came from drawing landscapes. His early training was in the London of the 1740s when he may have been the pupil of both Gravelot and Francis Hayman in St. Martin's Lane.

He returned to his native Sudbury in 1748 and soon after settled in Ipswich where he established a reputation as a portrait painter to the local gentry. In 1759 he moved to the fashionable resort of Bath and finally to London in 1774 where he soon became the favorite portraitist of George III. He was elected a founder member of the Royal Academy in 1768.

Despite Gainsborough's ability to achieve a good likeness in portraiture, his later landscape drawings were nearly all based on imagined scenes. These he composed from memory, and from the suggestive forms of bits of moss and charcoal arranged in candlelight upon his studio table. An eighteenth-century man, Gainsborough believed that the artist was obliged to select from the accidents of nature those effects which might be idealized into elevating form.

25

Upland Landscape with Figures, Riders, and Cattle (ill. p. 89)

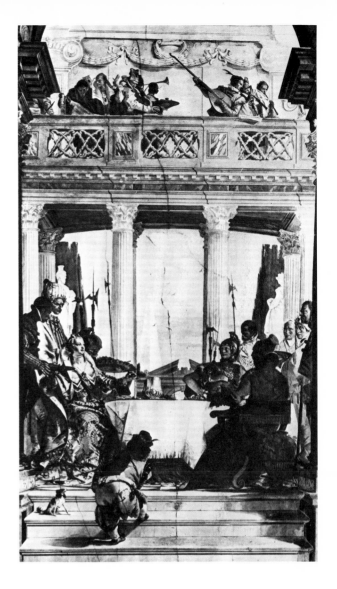

9 Giovanni Battista Tiepolo, *The Banquet of Antony and Cleopatra,* Palazzo Labia, Venice

Watercolor and oil on pale brown prepared paper, varnished
217 x 311 mm. (8⁹/₁₆ x 12¼ in.)
Provenance: Henry J. Pfungst; Mr. and Mrs. Sidney M. Ehrman
Exhibitions: Colnaghi, 1906, No. 69; Knoedler, 1923, No. 12; Ipswich, 1927, No. 147
Literature: Mary C. Woodall, *Gainsborough's Landscape Drawings,* London, 1939, No. 68; John Hayes, *Drawings of Thomas Gainsborough,* New Haven, 1971, No. 732
Fine Arts Museums of San Francisco, Gift of Mr. and Mrs. Sidney Ehrman (1952.63)

Gainsborough's landscape drawings are difficult to date with precision. However, this drawing was probably done in the early seventies, shortly before he settled in London. It was at this time that he began to experiment with varnished drawings like the *Upland Landscape.*

Gainsborough outlined his working method in a letter written on January 29, 1773 to his intimate friend, William Jackson, an amateur painter and composer: "Now before you do anything by way of stretching make the black and white of your drawing, the Effect I mean, and disposition in rough, Indian Ink shadows and your lights of Bristol made *white lead* which you buy in lumps at any house painters; . . . When you see your effect, dip it all over in skim'd milk," (*The Letters of Thomas Gainsborough,* ed. Mary Woodall, Greenwich, 1961, No. 103). Finally, three coats of spirit varnish were added to keep the drawing flat. Crucial to this technique was the substitution of white lead for chalk. The effect can be observed in the highlighting of the cattle in the *Upland Landscape.*

The San Francisco drawing was once one of nearly eighty Gainsborough drawings in the collection of the wine merchant Henry Joseph Pfungst (1844-1917) whose profusely illustrated, typewritten catalogue, now in the Mellon Collection, proves its authenticity.

Gaetano Gandolfi
San Matteo della Decima 1734-1802 Bologna

Gaetano Gandolfi followed his older brother and first teacher Ubaldo Gandolfi to Bologna sometime before 1748. He studied at the Accademia Clementina with Felice Torelli (1667-1748) and Ercole Graziani (1688-1765). Among his earliest known drawings are copies of frescoes by Nicolo dell'Abate and Pellegrino Tibaldi in 1756. In 1760 the two brothers visited Venice and were influenced by the paintings of Giovanni Battista Tiepolo. In 1767 Gaetano became a member of the Academy. Although primarily a painter, he was also an engraver. Like those of his older brother, Gaetano's paintings were much in demand, and he worked not only in Bologna but also in Rome, Naples, Brescia, Reggio, Rimini, Vienna, and Moscow. In 1787-1788 he visited London.

26

Grotesque Heads (ill. p. 82)
Pen, brown ink, and wash over traces of black chalk
255 x 181 mm. (10 x 7⅛ in.) (sight)
Exhibitions: San Diego, Fine Arts Gallery, *Baroque Paintings and Drawings,* 1973; Santa Barbara, Art Galleries, University of California, *European Drawings,* 1975, No. 17
Literature: Santa Barbara, Art Galleries, University of California, *European Drawings,* 1975, No. 17
Private Collection

The interest in grotesque heads ultimately traces back to Leonardo da Vinci's drawings in the late fifteenth and early sixteenth centuries. The publication of Della Porta's *De Humanae fisiognomiae* in 1586 started a vogue for carica-

ture in seventeenth-century Bologna among such artists as Agostino Carracci, Guercino, Crespi, and Mitelli. In the eighteenth century there was a renewal of interest by Donato Creti and Ercole Graziani, the teacher who presumably influenced Gaetano Gandolfi. Furthermore, when Gandolfi was in Venice in 1760 he met Francesco Bartolozzi who as early as 1745 had also drawn caricature heads. In general, the interest in phrenology, or the study of character through the shape of heads, was very much in fashion in the second half of the eighteenth century.

Like Leonardo, Gandolfi was interested less in caricaturing contemporary individuals than in studying the exceptionally ugly for its own sake. The four satyr heads, with their pointed ears and bulging eyes, go back to antique sources, while the aged man with staring eyes, long hooked nose, and toothless mouth is reminiscent of medieval representations of the philosopher type, particularly Dante.

Among the many studies Gaetano Gandolfi drew of grotesque heads are those in the Bologna Pinakothek, the Institute Nederlands in Paris (Inv. 4951), the collection of Molinari Pradelli (illustrated in Catherine Johnston, *Mostra di Disegni Bolognesi,* Florence, 1973, p. 107), and two drawings formerly at the Gallery Heim (Autumn catalogue, 1967, Nos. 74 and 75). Many of these heads were engraved by Luigi Tadolini in *Raccolta di Teste Pittotiche inventate e disegnati a penna dal Signor Gaetano Gandolfi Accademico Clementino.*

Ubaldo Gandolfi
San Matteo della Decima 1728-1781 Ravenna

At an early age Ubaldo Gandolfi went to Bologna to study at the Accademia Clementia with Felice Torelli (1667-1748) and Ercole Graziani (1688-1765). Together with his younger brother Gaetano, he visited Venice in 1760. In 1772 Ubaldo became *principe* of the Academy.

The position the brothers Gandolfi occupied in Bologna paralleled that of the Tiepolo family in Venice. Like the Tiepolos, they painted altarpieces, small devotional paintings, portraits, and large frescoes of mythological, religious, or allegorical subjects. Ubaldo, who was also an engraver and sculptor, was not only active in Bologna, but also in Rimini, Ravenna, Reggio, and St. Petersburg.

27

Martyrdom of a Bishop (ill. p. 83)
Pen, brown ink, and wash
300 x 206 mm. (11⅞ x 8⅛ in.)
Provenance: H. Shickman Gallery, New York
Private Collection

Compositionally the *Martyrdom of a Bishop* descends directly from Bolognese Baroque painting: a prone saint is stoned and speared while an angel and putti fly down bearing a palm and crown of victory. The drawing style is close to that of Ubaldo's paintings of the mid 1760s when he was primarily concerned with color and with creating a vibrant surface pattern. In the drawing this surface vibrance is achieved by means of the thin, nervous pen lines and the fluid but somewhat arbitrary use of wash.

28

Mary Magdalen *(ill. p. 82)*
Pen, brown ink, and wash
Inscribed in ink on lower margin: "Maria Madalena"; on the verso the notation: *D 316/ Gaetano Gandolfi*
253 x 96 mm. (9¹⁵⁄₁₆ x 3¾ in.)
Provenance: Adolph Loewi Gallery, Los Angeles
Grunwald Center for the Graphic Arts, University of California, Los Angeles, Gift of Mrs. Harold Hecht (1959.13.1)

In his drawing of Mary Magdalen Ubaldo Gandolfi employed still more dramatic contrasts of light and shade than in his earlier drawing of the *Martyrdom of a Bishop*. In this work of the 1770s Ubaldo continued to be interested in the decorative patterns produced by wash and in using thin, descriptive pen lines such as those which create the saint's left arm. The increase in the plasticity of the figure, however, reminds us that Ubaldo was not only a painter, but a sculptor as well. His sculpted prophets in S. Giuliano in Bologna are imbued with an almost Berniniesque drama; the active, crinkled drapery and wind-swept hair and beard have great vitality. In the drawing the penitence of the saint is more subtly conveyed through the use of wash to focus on the tightly clasped hands. There is animation, however, in the swirling locks of her hair.

Pier Leone Ghezzi
Rome 1674-1755 Rome

Although Pier Leone Ghezzi is best known as a professional caricaturist, his artistic career was actually wide-ranging. He succeeded his father Giuseppi Ghezzi, whose pupil he had been, as first painter to the pope (1708-1747). In that capacity he served as curator, conservator, and interior decorator of the papal establishment. He painted portraits and altarpieces, designed line and gem engravings, was active as antiquarian and agent-collector, and knew everyone of importance in the Rome of his day. But, as Anthony M. Clark has observed: "the endless pen ate up hours and years of Ghezzi's career and posterity has seen to it that the caricatures have eaten up the artist himself ("Pierleone Ghezzi's Portraits," *Paragone,* XIV [1963], p. 13).

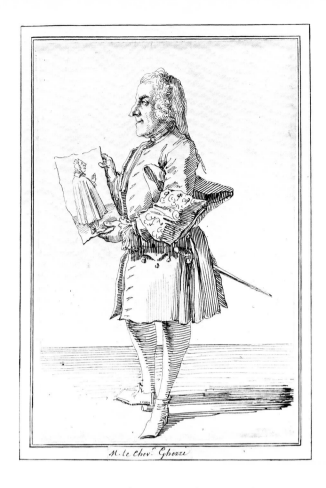

10 Pier Leone Ghezzi, *Self-Portrait,* 1724-1728, pen, brown ink, 273 x 182 mm., Janos Scholz Collection, New York

29

Caricature of a Gentleman *(ill. p. 59)*
Pen and brown ink
324 x 229 mm. (12¾ x 9 in.)
Exhibitions: Berkeley, *Master Drawings,* 1968, No. 37
Literature: Berkeley, *Master Drawings,* 1968, No. 37 (ill.); Los Angeles, *Drawings,* 1970
Los Angeles County Museum of Art, Gift of the Graphic Arts Council and the Art Museum Council (M. 65.41)

Ghezzi was the first important Italian painter of his day to devote himself to caricature as a profession. A shrewd observer, he produced thousands of drawings of members of the papal court and of the Roman aristocracy. He satirized musicians, opera singers, and prominent visitors to Rome — among them the French artists Edmé Bouchardon, Claude Vernet, Charles-Nicolas Cochin, Charles-Louis Clérisseau, and Jacques Germain Soufflot.

The Los Angeles drawing lacks the inscription Ghezzi often added to his drawings, and its subject, identified as the French Ambassador to Venice, cannot be documented. The costume suggests that the drawing was done about

Gillot inv. et sculp.

Est-ce vn enchantement, est-ce vne illusion?
En croiraye ma Peur, mes Yeux, ou ma Raison?
La dyn fier Negromant, et La de trois Sorcieres
Des fureurs du Sabat promptes avantcoureires
L'équipage, les cris, la sacrilege ardeur,
Dans ces iniques lieux annoncent la terreur.

Ici le maitre acteur de la scene tragique,
Donne en spectacle aux Demons furieux
Le supplice cruel de quelques malheureux,
Que regarde en tremblant vne trouppe magique.

Poisons, Philtres, Miroirs, sinistres instrumens,
Serpens, Dragons, Insectes, Ossemens,
Et tout ce que l'Enfer a produit de Misteres
Se trouve ici par vn funeste acord;
La Terre tremble et s'ouvre.... et qu'en sort-il encor?
Des Monstres dis-je, Et d'autres des chimeres.

11 Claude Gillot, *Witches' Sabbath,* etching with engraving added
by Jean Audran, 1722, Museum of Fine Arts, Boston, Ellen
Page Hall Fund

1730. In dress, pose, and the briskness of the line it is
similar to other inscribed caricatures of that time.
Ghezzi used the pose — a man facing left, legs at a forty-
five degree angle to each other, a hat under the left arm,
an object in the right — in at least three caricatures.
One of these drawings, a *Self Portrait* of 1724-1728, is in
the collection of Janos Scholz, New York (fig. 10).

Claude Gillot
Langres 1673-1722 Paris

Before coming to Paris in 1695 to study with the history
painter Jean-Battiste Corneille (1649-1695) Gillot studied
with his father, André-Jacques Gillot. By the age of thirty
his reputation as a decorator and painter of arabesques
was firmly established. Passionately interested in the thea-
ter, particularly the Italian comedy, Gillot designed sets
and costumes for the Grand Opera. He is remembered

today primarily because he was the teacher of Antoine
Watteau from 1704 to 1708. Admitted to the Academy as a
painter of modern subjects in 1715, Gillot was also a pro-
lific engraver who produced more than 345 works in this
medium.

30

Scene of Sorcery (ill. p. 50)
Pen and ink and red wash
Verso: Sketches in pen of animal caricatures
279 x 326 mm. (11$\frac{1}{16}$ x 12$\frac{7}{8}$ in.)
Exhibitions: Sacramento, *Master Drawings,* 1971, No. 78
Literature: Rosenberg, *Master Drawings,* 1970, No. 13,
Pl. 31; Sacramento, *Master Drawings,* 1971, No. 78 (ill.)
The E. B. Crocker Art Gallery, Sacramento (397)

Gillot is known to have made several drawings whose sub-
ject was sorcery. At least three were engraved. Although
a print does not appear to have been made after the Crocker

drawing, it is related to the pair of *Witches' Sabbath* etched by Gillot and completed with engraving by Jean Audran in 1722 (fig. 11). The second of the pair is illustrated in Bernard Populus, *Claude Gillot, Catalogue de l'Oeuvre Gravé*, Paris, 1930, fig. 30. A third etching was engraved by Caylus after a drawing by Gillot (Populus, No. 248).

The drawing, a night scene, shows a bearded man reading in a cemetery near a lake. There are four main groups in the rather loose composition: strange beasts emerging from a cave at the left; three witches in the center, one cutting down a dead body and two riding a broom; a boat carrying a woman holding a fan; and attendant figures being led by a witch on horseback. The drawing shows the mannerisms of Gillot's drawing style, particularly his tendency to elongate the figures and point the extremities.

Gravelot (Hubert-François Bourguignon d'Anville) Paris 1699-1773 Paris

A painter as well as a draughtsman and engraver, Gravelot was one of the foremost book illustrators of the eighteenth century. His elegant and delightful drawings express the Rococo taste for the intimate, the light hearted, and the decorative. Trained in Paris by Jean Restout (1692-1768) and in the atelier of François Boucher, Gravelot went to London in about 1732 and played an important role in introducing the Rococo style to the England of William Hogarth, Thomas Gainsborough, and Francis Hayman. During a fifteen-year stay he illustrated nearly one hundred books — among them two editions of Shakespeare — and designed two of the boxes at Vauxhall Gardens. His English career a success, Gravelot returned to Paris in 1745 and gained renown for his illustrations to the *Decameron* (1757-1761) among numerous other works.

31a, b, c

Three Preparatory Studies for the Frontispiece to the Second Canto of Voltaire's La Pucelle d'Orléans
(ill. pp. 70, 71)
Pen and ink, graphite, and chalk
a. 145 x 76 mm. (5⁹⁄₁₆ x 3 in.)
b. 135 x 78 mm. (5³⁄₁₆ x 3¹⁄₁₆ in.)
c. 132 x 78 mm. (5¹⁄₈ x 3¹⁄₁₆ in.)
Provenance: Roederer Collection; John Fleming, New York
Stanford University Museum of Art, Palo Alto, Mortimer C. Leventritt Fund (72.63. 1-3)

In Voltaire's notorious burlesque of the legend of Joan of Arc, the defense of France was neglected because of Charles VII's infatuation with Agnes Sorel. The satire included a series of bawdy scenes like the one illustrated in Gravelot's frontispiece to the Second Canto (fig. 12). Here, in the tent of John Chandos, an aerial St. Denis —

12 Frontispiece to the Second Canto, Voltaire, *La Pucelle d'Orléans*, 1762, Stanford University Library

"je suis Denis, et Saint de mon metier" — watches Joan embellishing the posterior of an English page named Monrose with the French *fleur-de-lis*. Later in the story, when the handsome page is discovered by the king in the boudoir of his lady love, the presence of the *fleur-de-lis* is attributed to the devil.

Gravelot's draughtsmanship is well illustrated in the three Stanford Museum drawings. Typically, he evolved his final version from a series of intermediary drawings in which he blocked out the figures, the clothing, and the setting. (Instead of drawing from live models, Gravelot sketched small mannequins with movable joints, silk bodies, and changeable costumes.)

Since Gravelot only occasionally etched his own designs, the final, carefully finished drawing would usually be copied by an engraver. In this instance the finished drawing may be missing from the Stanford series.

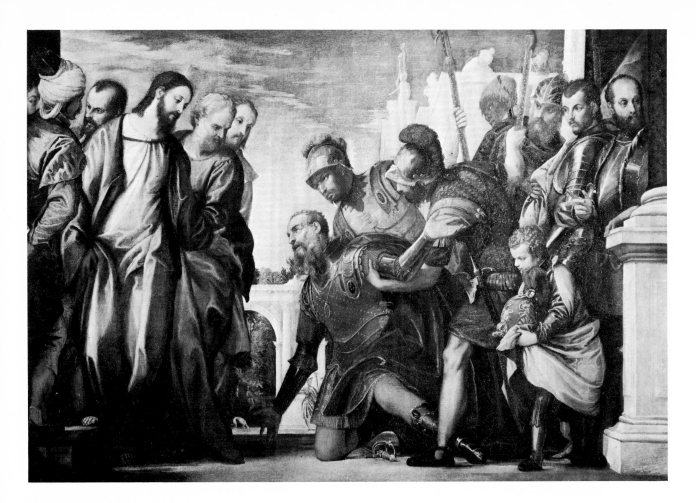

13 Paolo Veronese, *Christ and the Centurion,* William Rockhill
Nelson Gallery of Art, Kansas City

The authorized version of Voltaire's poem was published
in 1762, thirty years (and many pirated editions) after its
inception. Marcia Goldstein has uncovered evidence which
indicates that the Gravelot suite was in progress a few
years before the date of publication; in the correspondence
between Voltaire's publisher, Gabriel Cramer, and Grave-
lot, she finds a reference to the frontispiece of the Seventh
Canto in a letter dated April 1759 (*Voltaire's Correspon-
dences,* ed. Theodore Besterman, 1953-1964, 7537. Ms.
Goldstein is a graduate student in art history at Stanford
University).

Francesco Guardi
Venice 1712-1793 Venice

Francesco Guardi, who was trained in the studio of his
brother Giovanni Antonio Guardi (1698-1760), was the
brother-in-law of Giovanni Battista Tiepolo. As early as
the 1730s he was painting occasional landscapes or
capricci, and it is probable that he studied with Canaletto
(1697-1768) in the 1740s before the latter left for England
in 1746. However, Francesco was primarily a figure painter

until his brother's death in 1760. A year later he was
admitted to the equivalent of the painter's guild. Once in
1766 and twice in 1782 he was commissioned to record
important state functions. In 1784 he was elected to the
Academy of Fine Arts as a painter of architectural per-
spective. Guardi's paintings are characterized by a quick,
free *di tocco* manner of working which shows his artistic
descent from Sebastiano Ricci, Alessandro Magnasco,
Giovanni Antonio Pellegrini, as well as his brother.

32

Christ and the Centurion (after Veronese) *(ill. p. 78)*
Pen and brown ink over red chalk
488 x 368 mm. (19¼ x 14½ in.)
Provenance: A. Weinmüller, Munich; Seiferheld and Co.,
New York
Exhibitions: National Gallery of Art, Kimball Art
Museum, The St. Louis Art Museum, *Venetian Drawings
from American Collections,* 1974, No. 116
Literature: Weinmüller sale catalogue, Munich, Oct. 14,
1938, Lot 344, ill.; Heinrich Leporini, "Die Verstigerung
von Handzeichnungen bei A. Weinmüller," *Pantheon,*

I. Holzer inv.

I. C. Steinberger sculp.

Die Geburt Christi.
Willkommen Himels Printz, willkommen, Heil der Erden!
Das auf geringen Stroh vergnügt rühen kan.
Die Hirten komen itzt mit freüdigen Geberden,
Und beten Demüths voll dich ihren König an.
Es läst der Engel Schaar ein Freüden Lied erschallen,
Verkündiget ims Rüh und laüter Wohlgefallen.

NATIVITAS CHRISTI.
Salve Dei soboles, hujus lux aurea mundi,
Humani generis non dubitata salus.
Pastores veniunt, Christum reverenter adorant,
Aligerus chorus fundit ab ore melos:
Gloria in excelsis Domino, qui cuncta gubernat,
Pax et in hac terrâ nunc bona hominibus.

I.A.P. excudit.

14 *Adoration of the Shepherds*, engraving, Johann Christoph
 Steinberger, The E. B. Crocker Art Gallery, Sacramento (2-30)

14 (Oct. 1938), p. 330; E. R. Hunter, *Old Master Drawings
from the Collection of Mr. and Mrs. Lester Francis Avnet,*
New York, 1968, No. 27; Terisio Pignatti, "Un disegno di
figura di Francesco Guardi," *Studia di Storia dell'Arte in
onore di Antonio Morassi,* Venice, 1971, pp. 320-321;
Venetian Drawings from American Collections, intro. and
cat. by Terisio Pignatti, International Exhibitions Foun-
dation, 1974, No. 116 (ill.)
Private Collection

While working in the studio of his brother Giovanni
Antonio, Francesco Guardi is known to have made copies
of paintings by Sebastiano Ricci and other Venetians. This
drawing is modeled on a version of Paolo Veronese's *Christ
and the Centurion,* either on the one in Kansas City (fig. 13)
or on the print of 1758 by P. H. Andr. Killian after the
Dresden version. According to Terisio Pignatti (*Venetian*

Drawings from American Collections, International Exhi-
bitions Foundation, Washington, 1974, p. 55), it was drawn
around 1760 and thus is nearly exactly contemporaneous
with Jean-Honoré Fragonard's more faithful copy of
Veronese's *Adoration of the Magi* of 1761 (Cat. 22). Guardi
changed the format of the painting from horizontal to verti-
cal and has added an elaborate architectural setting — at
the left a Tempietto and at the right a porch, a temple, and
even a bell tower. He retained all the figures except for one
warrior at the right but placed them further back in space
and added the patterned paving in the foreground. Guardi
also succeeded in endowing the central figures with a
greater sense of movement. This is particularly true of the
figures of the kneeling centurion and the two men who
appear to be rushing forward to support him. The rapid,
wavering lines of the drawing create the same agitated,
nervous rhythm which characterizes Guardi's paintings.

Johann Evangelist Holzer
Burgeis 1709-1740 Clemenswerth

Johann Evangelist Holzer was the most gifted of the circle of painters who studied with Johann Georg Bergmüller in Augsburg. He came to Augsburg from the southern Tyrol in 1731 after studying with Nicolas Auer.

Holzer's earliest decorations and his most engaging were paintings done on the façades of houses in Augsburg. Although now destroyed, these are known through his sketches, through studies and engravings by J. E. Nilson, and from the accounts of observers. Holzer created in these sketches figures extraordinary for their ease and liveliness. He built them up in tones of light and shade, a method he seems to have learned from a study of engravings by Rembrandt and Watteau, artists whose works he copied. Basically, however, the style he developed was highly original and can best be seen in the illusionistic reach of the magnificent ceiling of the abbey church of Münsterschwarzach (1737-1740).

33
Adoration of the Shepherds (ill. p. 62)
Pen and ink and wash
147 x 242 mm. (5⅜ x 9½ in.)
Provenance: C. Rolas du Rosey
Exhibitions: Sacramento, *The German Masters,* 1939, No. 50; Sarasota, *Central Europe,* 1972, No. 64
Literature: Sacramento, *The German Masters,* 1939, No. 50; Sacramento, *Master Drawings,* 1971, p. 153; Sarasota, *Central Europe,* 1972, No. 64
The E. B. Crocker Art Gallery, Sacramento (64)

Holzer's drawing, *The Adoration of the Shepherds,* was one of several engraved by Johann Christoph Steinberger (1680-1727) who also engraved the works of Watteau. In all, Steinberger engraved six scenes from the Life of Christ and two scenes from the Life of St. John the Baptist after designs by Holzer. The print (fig. 14) from this drawing was published, with texts in German and Latin, by Johann Andreas Pfeffel, an Augsburg publisher. Holzer worked for him as a draughtsman from 1736 to 1738 and decorated his house *al fresco* with the story of Castor and Pollux.

Holzer's drawing is typical of the German Rococo, particularly in the delicate border with shell and plant forms, ribbons, gardening tools, and palm leaves. The slender, elegant figures are arranged in an asymmetrical but balanced composition which is usual in Holzer's drawings.

Jean-Baptiste Huet
Paris 1745-1811 Paris

Jean-Baptiste Huet was the son of Nicolas Huet the elder (c. 1718-1780), a painter of animals. Two of his sons also became artists, Nicolas Huet the younger (b. 1770) and Jean-Baptiste Huet the younger (b. 1772). Huet studied drawing with Charles Dagomer (d. 1768), in 1764 became a pupil of Jean-Batiste Leprince, and also worked with François Boucher. Huet, who was a painter and engraver of animals and landscapes, in 1769 became a member of the Academy as a painter of animals. Only once, in 1779, did he exhibit a mythological painting. It was very badly received. He also worked for the Manufacture des Gobelins and for the porcelain factory at Sèvres. A large number of his drawings were reproduced in engravings and aquatints.

34
A Poppy Plant (ill. p. 95)
Red chalk
Signed and dated, lower left: *J. B. Huet 1780*
Sheet numbered in ink, lower left: *160*
492 x 324 mm. (19⅜ x 12¾ in.)
Provenance: James D. Phelan
Fine Arts Museums of San Francisco, James D. Phelan Bequest Fund (1932.514)

As many of Huet's drawings of animals and plants were done from nature, it is probable that this large drawing was made at the Jardin des Plantes in Paris. Phyllis Hattis suggests (in her forthcoming catalogue of the French drawings in the Fine Arts Museums of San Francisco) that the drawing was intended to be engraved. The line loosely contours the leaves and flowers and the shading is made with cross-hatching. The number 160 at the lower left suggests that it was to be one of a series. However, no engraving after the drawing is known.

The individual study of flowers ultimately goes back to seventeenth-century Dutch still-life painting and to the continuation of the genre into the eighteenth century by such important Dutch artists as Jan van Huysum (1682-1749). Huet was undoubtedly familiar with his drawings and with the engravings after them.

Filippo Juvarra
Messina 1678-1736 Madrid

Filippo Juvarra first studied with his father, a talented silversmith. In 1703-1704 he went to Rome to join the studio of the architect Carlo Fontana (1638-1714). In 1708 he entered the service of Cardinal Ottoboni for whose theater in the Cancelleria he produced extremely bold stage designs. He entered the service of Vittorio Amadeo II of Savoy in 1714 and worked for him first at Messina and then at Turin. As "First Architect to the King," he enjoyed an international reputation paralleled only by that of Giovanni Battista Tiepolo a generation later. Between 1719 and 1720 he traveled to Portugal to plan the palace at

Mafra for King John V and went on to visit London and Paris. He went to Madrid in 1735 to design a royal palace for Philip V and through the years produced several major buildings in Turin, among them the Palazzo Madama (1718-1721), the Superga (1717-1731), and the castle at Stupinigi (1729-1733).

35

Tempietto (ill. p. 56)
Pen, brown ink, and wash
Numbered in pen, upper left: *912*
156 x 212 mm. (6⅛ x 8⁵/₁₆ in.)
Provenance: Sotheby & Co., London, Nov. 25, 1971, Lot 143
Private Collection

In 1708 Juvarra began to design stage sets for Cardinal Ottoboni at the Cancelleria. The Cardinal was the foremost patron of the opera in Rome and in 1708 alone produced operas by Alessandro Scarlatti, George Frederick Handel, and Domenico Scarlatti. Juvarra remained in his service until 1712 when he left Rome to work for Vittorio Amadeo II of Savoy. Since his new patron was less interested in the theater than the Cardinal, the majority of Juvarra's theater designs were produced early in his career.

The subject of this drawing is a Tempietto — a small, round, classical temple. Interest in the Tempietto as an architectural form revived in Rome during the Renaissance when Bramante built one at S. Pietro in Montorio. Juvarra frequently included either a one- or two-storey Tempietto in his designs for stage sets (see M. Viale Ferrero, *Filippo Juvarra scenografo e architetto teatrale,* Turin, 1971, pp. 139, 144, 230, 316 for some examples). Like many of the theater designs, the composition is closed at the two sides by projecting architectural wings.

Hendrik Kobell
Rotterdam 1751-1779 Rotterdam

After traveling in the Netherlands and in England, Kobell enrolled as a pupil at the Academy of Drawing at Amsterdam. He was a protegé of Jacob de Vos and the engraver and collector Ploos van Amstel. His fame rests on his prolific output as an engraver of marine scenes. He exhibited at the Free Society in London in 1770.

36

The Dutch Fleet off Batavia (ill. p. 87)
Watercolor
408 x 548 mm. (16 x 22½ in.)
Literature: Sacramento, *Master Drawings,* 1971, p. 154
The E. B. Crocker Art Gallery, Sacramento (1273)

Batavia, the name given by the Dutch in 1619 to the Javan-

15 Pieter van de Velde, *Warships and Barques before a Town,* private collection, Germany, courtesy of Galerie Müllenmeister, Solingen

ese town of Jacarta, was the headquarters of the Dutch East India Company. To protect its monopoly on all Dutch Far Eastern trade, the company needed warships. Not only was there the threat of encroachment from England and France but also from a Dutch rival, the West India Company. In this watercolor, Batavia is the town in the background in front of a mountain, and the two rows of warships in battle formation are Dutch. Although cannon smoke envelopes the ships at the right, no enemy vessels are visible.

Like the skating scene of Andries Vermeulen (Cat. 60), Kobell's marine scene is an example of the continuation into the eighteenth century of subjects and compositions firmly established in the seventeenth century (fig. 15). The dark foreground and bands of light in the near and far distance was a compositional device developed by such first generation seventeenth-century painters as Jan van Goyen. The convention was continued by later marine painters such as Abraham van Beyeren, the Van de Veldes, and Backhuysen.

Carlo Labruzzi
Rome 1765-1818 Perugia

Carlo Labruzzi was the most important of three brothers, all of whom were painters. In 1781 he joined the Congregazione Virtuosi and in the following year produced his first important painting, *Diana and the Hunt* for the Casino Borghese. In 1796 he became a member of the Academy of Saint Luke and in 1814 was made director of the Academy at Perugia. Labruzzi was influenced by Giovanni Battista Piranesi and painted landscapes of decaying Roman ruins. Also an engraver, his prints include copies of Masaccio

and Michelangelo, views of Rome, costumes of peasants, and scenes from village life.

37

Tiberius' Grotto at Sperlonga (ill. p. 102)
Watercolor over graphite
Inscribed on verso: *Gratta Antigua di Tiberio a Sperlongi*
397 x 537 mm. (15⅝ x 21⅛ in.) (sight)
Provenance: P. and D. Colnaghi, London
Private Collection

In 1957 a spectacular discovery was made in Tiberius' Grotto at Sperlonga. Within this grotto, which had originally been a dining room in the imperial villa, were found sculpture groups illustrating scenes from the *Odyssey*. These were placed in two niches with water cascades and a pool in the center. Research indicates that the groups of Odysseus and Palladion, and Odysseus' helmsmen are by the same sculptors — Hagesandros, Athanadoros, and Polydoros — who created the *Laocoön,* the Hellenistic sculpture group found during the Renaissance. It is believed that the groups were brought from Rhodes or Asia Minor when the grotto was refashioned by Tiberius in A.D. 29.

Labruzzi's interest in *Tiberius' Grotto at Sperlonga,* as in many of his other watercolors, was in the juxtaposition of majestic ruins of classical antiquity and peaceful scenes of contemporary life. Here, the men seated in the foreground are visually overwhelmed by the huge cave with its three interior niches and the wall ruins at the right and above the mouth of the grotto.

Nicolas Lancret
Paris 1690-1743 Paris

Nicolas Lancret, a follower of Watteau, was an immensely popular painter during his lifetime. Born into a working-class Parisian family, as a boy he was sent to study engraving with Pierre Dulin, a minor history painter. Soon after, Lancret entered the Academy, but in 1708 he was expelled for misbehavior. In about 1712 he became the student of the engraver Claude Gillot and soon began to study with Antoine Watteau. He became a member of the Academy in 1719 with the presentation of a *fête galant.* From the 1720s on he exhibited paintings of this kind at the Exposition de la Jeunesse and later at the Salon.

In comparison with Watteau, Lancret seems the more academic and robust painter. He uses shimmering colors — more fully saturated than Watteau's — and exhibits great spirit and liveliness in his work. Many of his paintings were inspired by the fables of La Fontaine and by the performances of the Théâtre Français.

38

Figure of a Gentleman (ill. p. 60)
Red chalk
Inscribed on verso: *V L Egg*
153 x 95 mm. (6 x 3¹¹/₁₆)
Provenance: Adolph Loewi Gallery, Los Angeles
Exhibitions: Santa Barbara, *Drawings,* 1970, No. 43
Literature: Santa Barbara, *Drawings,* 1970, No. 43 (ill.)
Santa Barbara Museum of Art, Gift of Mrs. David Park, (59.15)

Like many other artists, Lancret is known to have copied the works of Antoine Watteau. This drawing is a copy of a red crayon Watteau drawing in the Ecole des Beaux Arts, Paris. (See Karl T. Parker and J. Mathey, *Antoine Watteau, Catalogue Complet de son Oeuvre Dessiné,* Vol. I, Paris, 1957, p. 10, No. 60, ill.) Watteau's drawing includes not only the original of this figure but also a study of the same model seated and two sketches of a woman's head. The attribution came with the drawing but is supported by Lancret's deliberate emulation of Watteau's work. The drawing is more vigorous and less delicate in its handling than is Watteau's work, particularly in the hatching. Also the transformation of the facial expression, from the little pinched and worried face of Watteau's model into the flat, cheerful prettiness of Lancret's, epitomizes the difference between the two men as artists.

Although this drawing is not known to be related to any specific Lancret painting, in his work he often used similar tall and elegantly proportioned figures of gentlemen wearing costumes of this kind.

François Lemoine
Paris 1688-1737 Paris

François Lemoine, who became first painter to the king in 1736, was the son of a postilion. His father died when Lemoine was a child, and his mother was remarried to the portrait painter Robert Levrac-Tournières (1667-1752) who gave Lemoine his earliest training. This was later supplemented by study with Louis Galloche (1670-1761), a friend of Roger de Piles and an admirer of Rubens whose influence is apparent in the work of Lemoine. Lemoine was received into the Academy in 1718 and visited Italy in 1723.

A great decorator, Lemoine occasionally painted portraits, religious subjects, and landscapes, but his most important works were mythological scenes: the *Apotheosis of Hercules* in the Salon de la Paix at Versailles and *Hercules and Omphale* at the Louvre. At the height of his career, in 1737, Lemoine killed himself.

39

Head of Omphale *(ill. p. 51)*
Red and black chalk with white highlights
234 x 165 mm. (9¹/₁₆ x 6½ in.)
Exhibitions: Rosenberg, Ontario, *French Master Drawings,* 1972, No. 79
Literature: *The Art Quarterly,* 1971, p. 374; Rosenberg, Ontario, *French Master Drawings,* 1972, No. 79
University Art Museum, Berkeley, Gift of Mr. and Mrs. John Dillenberger in memory of their son, Christopher Karlin (1971.16)

Lemoine's sensual chalk drawing of a woman's head is a preparatory study for the painting *Hercules and Omphale* which was begun in Rome in 1724 and is now in the Louvre (fig. 16). A study for the torso of the female figure is in the British Museum.

Pierre Rosenberg writes (*French Master Drawings,* 1972) that the Berkeley drawing and another in Ann Arbor are the only two Lemoine drawings in the United States outside New York. The Metropolitan Museum of Art has a group of five, and two others are in the Pierpont Morgan Library.

Jean-Baptiste Le Paon
Paris 1738-1785 Paris

As a soldier during the Seven Years War, Jean-Baptiste Le Paon first sketched the battle scenes which later earned him his reputation. On the advice of François Boucher and Carle Van Loo, he became a student of Francesco Giuseppe Casanova who specialized in painting war scenes and who was the brother of the famous adventurer.

Le Paon, refused admission to the Academy, was associated with the Prince of Condé whose residences at Chantilly and the Palais Bourbon he decorated. He also made a significant contribution to the decoration of the Ecole Militaire. Frustrated by a lack of dramatic subject matter, Le Paon attempted to work for Catherine the Great. Writing to an intermediary in 1781, he expressed the hope that her war against the Turks would provide the grand battle which, if he could paint it, would assure his immortality as a painter. His hope was not fulfilled, and he died in 1785, just before the French Revolution, which would undoubtedly have provided the material he craved.

40

A Prince Ploughing with Peasants Watching Him
(ill. p. 86)
Pen and ink and wash
355 x 583 mm. (13¾ x 21 in.)
Signed twice, at lower left: *De Paon;* and at lower right: *Le Paon*

16 François Lemoine, *Hercules and Omphale,* Louvre, Paris

Exhibitions: Sacramento, *Master Drawings,* 1971, No. 90
Literature: Rosenberg, *Master Drawings,* 1970, No. 18, Pl. 36; Sacramento, *Master Drawings,* 1971, No. 90 (ill.)
The E. B. Crocker Art Gallery, Sacramento (448)

In Le Paon's charming pen drawing soldiers, peasants, coachmen, and postilions pause attentively to watch the noble personage who walks behind a plough. This may have been the Prince of Condé, Le Paon's patron. The Prince's involvement, if only a brief one, with the agricultural life of his subjects reflects the fashion for a return to a simpler, more honest way of life. Fostered by Jean Jacques Rousseau's philosophy of nature and the pure state of primitive man, this fashion reached its height in Queen Marie Antoinette's dairy at Versailles.

Jean-Baptiste Le Prince
Metz 1734-1781 Saint-Denis-du-Port

Jean-Baptiste Le Prince, a student of François Boucher, is best known for his paintings and drawings of Russian themes. During a five year stay in St. Petersburg (1758-1763) he sketched a variety of lively genre scenes in the costumes and settings of the day. Their bizarre and picturesque quality made them an enormous popular success in France when they appeared in the mid 1760s. Le Prince exploited the exotic appeal of *russerie* from the time of his

reception at the Academy with *Le Baptême Russe* (1765) until his death in 1781. A fine watercolorist, Le Prince reproduced many of his works in aquatint, a medium he used with distinction.

41

Landscape with Shepherds (ill. p. 94)
Pen, brown ink, and wash
Signed and dated lower right: *Le Prince 1778*
277 x 363 mm. (10⅞ x 14¼ in.)
Literature: Sacramento, *Master Drawings,* 1971, p. 155
The E. B. Crocker Art Gallery, Sacramento (446)

In his imaginary landscape of 1778 Le Prince treats boulders and rocks with a lingering feeling for the *rocaille* design of the earlier eighteenth century. But the mood, one of picturesque sublimity, is an echo of Salvator Rosa's Neapolitan studies, popular inspirations throughout the century in which small figures exist in a wilderness setting. These elements of design and aesthetic are here combined with a conception of the landscape which also reflects the seventeenth-century Dutch tradition.

Jean-Guillaume Moitte
Paris 1746-1810 Paris

Trained as a sculptor, Jean-Guillaume Moitte was a *Prix de Rome* winner in 1771. Little is known, however, of his subsequent work. He did designs for the goldsmith Auguste in Paris in the early eighties, and the architect Pierre Rousseau commissioned him to work as a decorator at the Hotel de Salm-Krybourg, the town residence of Prince Frederic. Moitte's contribution, a twenty-foot bas-relief, *The Festival of Pales* (c. 1783) was the major ornament of the Court of Honor. Moitte was appointed to the Royal Institute and the Academy of Toulouse. A few of his drawings are in the museum at Lille.

42

Ritual Marriage Preparation (ill. p. 92)
Pen, brown ink, and wash over light grey chalk
Signed: *Moitte Sculpteur 1781*
335 x 321 mm. (13³⁄₁₆ x 12¹¹⁄₁₆ in.)
Exhibitions: Sacramento, The E. B. Crocker Gallery, *Classical Narratives in Master Drawings,* Sacramento, 1972, No. 21
Literature: Rosenberg, *Master Drawings,* 1970, No. 19, Pl. 37; Sacramento, *Master Drawings,* 1971, p. 157; The E. B. Crocker Gallery, *Classical Narratives in Master Drawings,* ed. Seymour Howard, Sacramento, 1972, No. 21 (ill.)
The E. B. Crocker Art Gallery, Sacramento (451)

Moitte's drawing depicts the elaborate Roman ritual of preparing the bride for marriage. The bride — the heavily draped figure at the right — is led to the sacrificial flame by the groom. At the couple's feet a kneeling girl proffers a garland of flowers, a symbol of fertility.

The scene is based on the ancient Roman wall painting, the *Aldobrandini Wedding* which was the popular source of marriage rituals *all'antica* in artistic circles at this time. It is likely that Moitte would have seen the original during his brief stay at the French Academy in Rome during the early seventies. He would also have been familiar with the frieze-like ornamentations used, from the mid century onwards, by progressive young French and English architects. In 1768 Robert Adam had commissioned his chief decorator Antonio Zucchi to produce *A Roman Marriage* for the hall at Mersham-Le-Hatch in Kent. This work, too, was based on the *Aldobrandini* scene. In France the sacrifice to the altar of Love was a frequent subject of paintings beginning with Michael van Loo's *Première Offrande à l'Amour* in 1761 and including variations by Greuze, Vien, and Fragonard.

George Morland (attributed to)
London 1763-1804 London

George Morland, the gifted and amiable painter of picturesque English scenes, led a reckless, tragic, and legendary life, drinking himself to death at the age of forty-one. Up to his ears in debt, Morland was able to avoid prison until just before his death by producing a stream of popular, often sentimental pictures — village inns, shaggy ponies, sea scenes, and children at play. "He would paint a picture in the time that many would spend seeking for a subject," George Dawe wrote in his Life of the painter (1807). Dawe took Morland (and his uncritical public) to task for the carelessness of his drawing, but the painter refused to correct these faults and is reputed to have said: "they will pass as the proofs of a fiery genius" (George Dawe, *The Life of George Morland,* London, 1807, p. 226). In truth, Morland's genius lay in his painterly talent for rendering the tonal effects of textures and surfaces in patches of light and shade, and not in the linear quality of his work.

Morland, who had an astute sense of what the public would buy, was among the first to produce his paintings at his own expense and sell them, free from the constraints of commission, through an agent. Though he consciously tailored his subject matter to provide agreeable, domestic pieces, he treated them with the freedom and ease that were his natural gifts.

43

Farmyard Scene (ill. p. 102)
Watercolor

Signed and dated, lower left: *G. Morland pinx. 1791*
313 x 405 mm. (12⅜ x 16 in.)
Fine Arts Museums of San Francisco, Gift of Mr. Herbert
Fleischhacker (1930.9)

In the same year as this drawing, 1791, Morland painted
the picture which brought him his greatest fame, *Inside of
a Stable*. He immediately abandoned sentimental genre
scenes like *Children Playing at Soldiers* and *Blind Man's
Buff* and turned almost exclusively to simple, rustic scenes
like this one. Its composition — with the barn at the right,
the tree and fence at the left, and the figures in the center
— is characteristic of his designs. So, too, are the technical
means he used to produce contrasting textures and forms.
The signature, however, is like no other Morland auto-
graph, and copies exist of hundreds of his works.

The focal point of the drawing is the little Welsh carter's
pony, a frequent subject of Morland's work. As a boy
apprenticed to his father as a painter, Morland copied
Stubb's *Anatomy of the Horse,* and his interest in horses
persisted throughout his work. In this drawing, his con-
cern is less with the animal's musculature than with his
roguish personality. Morland loved to draw animals — his
favorite being the pig, and he kept many pets at his home.

Nicolaas Muys
Rotterdam 1740-1808 Rotterdam

Muys studied with his father, Willem Muys (1712-1764), a
painter of genres and portraits, and with the painter and
decorator Aart Schoumann (1710-1792). His brother
Robert (1742-1825) was an engraver, and his sister Cornelia
(b. 1745) was a miniaturist. In 1762 he worked briefly at
The Hague. In 1782, 1783, and 1786 he was director of the
Rotterdam Saint Lucas Guild. He became a corrector for
the drawing society *Hierdoor tot Hooger (Through this
[society] toward the better)*. Muys mainly painted theater
scenes, interiors, and portraits.

<u>44</u>

Portrait of a Woman in a Bonnet (ill. p. 85)
Black and red chalk
217 x 159 mm. (8⅛ x 6¼ in.)
Provenance: Gropper Art Gallery, Cambridge
Private Collection

This portrait of an unidentified woman is from a sketch-
book of portraits which is dated 1771 on several sheets.
There are two other drawings from this sketchbook in
California: the *Figure of a Sculptor* in the University Art
Museum, Berkeley (fig. 17) and a *Portrait of a Man in
Profile, Facing Left* in the same collection as this drawing.
In all three of these works Muys uses red chalk for the

17 Nicolas Muys, *Figure of a Sculptor,* 1771, red and black chalk,
206 x 159 mm., University Art Museum, Berkeley, Gift of the
Joseph Goldyne Family

faces and hands only and black chalk for the remainder of
the drawings.

The sitter, placed against a dark background, is lit from
the left, as if by candlelight. The dramatic result is remi-
niscent of such second generation Dutch *Caravaggisti* of
the seventeenth century as Godfried Schalcken (1643-1706),
but the sense of intimacy and tenderness which radiates
from the slightly smiling bourgeois woman is typical of the
eighteenth century. As Roger Mandel has pointed out
(*Dutch Masterpieces from the Eighteenth Century,*
Minneapolis Institute of Arts, Minneapolis, 1971, p. 69),
"Muys's theater scenes, interiors and portraits are perhaps
the most delicately conceived and painted in Dutch
eighteenth-century art. At times he ranks near (Cornelis)
Troost and his closest French counterpart, Garnier."

Johann Friedrich Ludwig Oeser
Dresden 1751-1792 Leipzig

J. F. L. Oeser, the son of the well-known painter Adam
Oeser (1717-1799), was an engraver as well as a painter.
He was a professor of drawing at the Academy in Leipzig

from 1767 to 1774 and later a teacher at the Academy in Dresden. Little is known about his life.

45

Landscape (ill. p. 94)
Watercolor
Inscribed, in the center above the hill: *Brumlu . . .*
290 x 425 mm. (11⅜ x 16¾ in.)
Exhibitions: University of Kansas, *German and Austrian Prints,* 1956, No. 41; Sacramento, *Master Drawings,* 1971, No. 96
Literature: University of Kansas, *German and Austrian Prints,* 1956, No. 41; Sacramento, *Master Drawings,* 1971, No. 96 (ill.)
The E. B. Crocker Art Gallery, Sacramento (68)

Even if the undecipherable place name, *Brumlu . . .,* did not occur on this drawing it would still appear to be a topographically accurate rendering of the German landscape. The fresh watercolors vividly record a day in early autumn when the background hills were turning brown and the leaves were just beginning to change color.

Hubert Robert
Paris 1733-1808 Paris

Having first studied with the sculptor Michel-Ange Slodtz (1705-1764), Robert went to Rome in 1754, under the protection of the French ambassador, M. de Stainville, later the duc de Choiseul. In Rome he studied at the French Academy where he became close friends with Jean-Honoré Fragonard and the Abbé de Saint-Nom. With the Abbé he took a trip to Naples in 1760. Robert returned to France in 1765 and the following year became a member of the Academy into which he was accepted as a master of *tableaux de place.* He was imprisoned at the time of the French Revolution, and later, like Fragonard, he was made a member of the Commission de Musée français.

46

View of Tivoli (ill. p. 75)
Red chalk
Signed, lower right: *Robert*
292 x 418 mm. (11⁷/₁₆ x 16½ in.)
Provenance: Sotheby & Co., London, June 27, 1974, Lot 39
Stanford University Museum of Art, Palo Alto, Gift of the Committee for Art at Stanford (74.197)

This large and imposing drawing of a river, trees, and buildings in the town of Tivoli was drawn during one of the many visits Hubert Robert made to Tivoli in the early 1760s (often in the company of Fragonard). In the drawing Robert's primary interest was in capturing the differences in color value and texture within the plant foliage. He was able to achieve a sense of these qualities by varying the density of the chalk and by controlling the direction of the broad parallel lines he used for shading. These go in the same direction for each group of plants but in different directions from one group to another, from grass to bushes, to the several types of trees, even to those reflected in the river.

47

Old Fountain and Pyramid of Cestius, Rome (ill. p. 76)
Graphite over black chalk
Signed and dated on the pyramid: *H. Robert 1782*
359 x 286 mm. (14⅛ x 11¼ in.)
Private Collection

Many of Robert's drawings combine imaginary elements and actual monuments. In this drawing the fountain and statue are imaginary while the pyramid of Cestius in the background was one of the best known Roman ruins from antiquity. Located near the Saint Paul Gate on the road to Ostia, the pyramid was the tomb of Caius Cestius who died in 43 B.C. The pyramid later became part of the city's system of defense, and after the Reformation the Protestant cemeteries were located near the monument.

The drawing is probably a counter proof of another drawing by Robert. By the 1760s it had become a common practice for artists to make these counter-impressions of their drawings. A piece of damp paper would be placed on top of the original chalk drawing, and pressure would be brought to bear upon it in order to transfer some of the original chalk to the counter-proof. The artist would then, as in the drawing, reinforce the lines on the counter-proof. The practice seems to have developed from a combination of the demand for drawings and the artist's desire to have a record of his best compositions. When Robert died, his inventory included more than 200 counter-proofs of his own drawings.

George Romney
Dalton-in-Furness 1734-1802 Kendal

George Romney, born in Lancashire in the north of England, moved to London in 1762. He enjoyed a moderate success as a history painter before turning to portraiture. In 1773 he went to Rome for two years. There an acquaintance with Johann Heinrich Fuseli aroused his interest in the sublime. He returned to London and soon became extremely successful as a portrait painter, but Romney always believed that his historical paintings were of greater importance.

In 1782 he became infatuated with Emma Hart, who later became Lady Hamilton. Obsessed with her beauty and

under stress from overworking as a portraitist, Romney turned increasingly to subjects of an irrational and supernatural kind. Gradually his mental state deteriorated. In 1798 he returned to the care of his wife in Kendal, and there he died insane.

48

The Fiend Conjured Up by Bolingbroke (ill. p. 101)
Pen and grey wash over graphite
Verso: faint graphite of looming figure
Stamped, lower left: *AdP;* written in pencil: *46*
398 x 293 mm. (15⁵/₈ x 11⁹/₁₆ in.)
Provenance: Alfred de Pass; Zeitlin and Ver Brugge, Los Angeles
Literature: *Antiques Magazine,* November 1964, p. 601; *Burlington Magazine,* June 1967, p. xcix
Private Collection

In the late 1780s Romney began his involvement with the project which brought English history painting into focus: the Boydell Shakespeare Gallery. His main contribution was a painting of the shipwreck scene from *The Tempest.* Another painting by Romney intended for the Boydell Gallery and even more sublime and terrifying in its subject matter was *Bolingbroke Conjuring Up the Fiend.* According to the artist's son John Romney, however, the painting was destroyed as a result of being stored without adequate protection during a winter when Romney stayed at Hampstead (*The Memoirs of the Life and Works of George Romney,* London, 1830, p. 154).

Bolingbroke Conjuring Up the Fiend illustrates scene iv from Act I in Part II of Shakespeare's *Henry VI.* At the beginning of the scene, Bolingbroke, speaking to the Duchess of Gloucester, describes the setting:

... wizards know their times:
Deep night, dark night, the silent of the night,
The time of night when Troy was set on fire,
The time when screech-owls cry, and ban-dogs howl,
And spirits walk, and ghosts break up their graves;
That time best fits the work we have in hand.
Madam, sit you, and fear not: whom we raise
We will make fast within a hallow'd verge.

Shakespeare's stage directions then continue: "Here do the ceremonies belonging, and make the circle; Bolingbroke or Southwell reads, *Conjuro te, etc.* It thunders and lightens terribly; then the Spirit riseth." The fiend proceeds to prophesy falsely the downfall of the Duchess and the subsequent tragedies throughout the play.

Romney made a number of preparatory drawings for the painting. Five are in the Fitzwilliam Museum, and a sixth, *Bolingbroke and Head of Fiend,* is in the Yale University Art Gallery (fig. 18). At the right in the Yale drawing is a

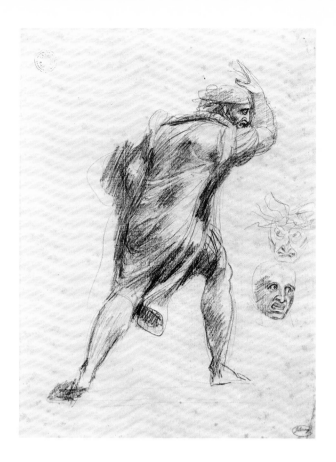

18 George Romney, *Bolingbroke and the Head of Fiend,* c. 1786-1789, pencil, 514 x 381 mm., Yale University Art Gallery, Gift of Mr. and Mrs. J. Richardson Dilworth

rapid sketch of the head of the fiend which is more fully developed in the full figure of the fiend in this drawing. The inventive quality of this later drawing illustrates Romney's fertile imagination and his ability to simplify form in a free and evocative way.

Thomas Rowlandson
Spitalfields 1756-1827 London

Rowlandson moved to London with his aunt in 1764. He was a student at the Royal Academy School between 1772 and 1778 and at some point during these years made his first trip to Paris. In 1784, along with his friend Wigstead, Rowlandson toured southeast England. The result was a book of Rowlandson's drawings and Wigstead's comments, *Tour in a Post Chaise.* The two traveled to Brighton in 1789 and to Wales in 1797, producing a book after each trip.

In the early 1780s Rowlandson exhibited a number of large, carefully executed watercolors at the Royal Academy. Soon thereafter he began to produce the stream of social and political satires and caricatures for which he is known. In the late 1780s and 1790s he made several trips to the continent, and dated drawings of continental views exist

19 *Portrait of Joseph Gulston,* 1828, engraving, S. Bellin, Henry
E. Huntington Library, San Marino

from the years 1791, 1792, and 1794. At the end of the
decade he began working for the publisher Rudolph Acker-
mann. In response to Ackermann's pressure he produced
The Microcosm of London in 1808-1810; *The Three Tours of
Doctor Syntax* in 1812-1821 (this became his best known
series), and *The English Dance of Death* in 1815-1816.
There was another visit to Paris in 1814, and sometime
after 1820 he visited Italy where he produced careful studies
after antiquities.

49

Place des Victoires (ill. p. 97)
Pen and ink and watercolor over graphite
359 x 527 mm. (14^1/$_8$ x 30^3/$_4$ in.)
Etched and published by Samuel Alken, November 1789
Provenance: R. A. Lewis, Nicosia
Exhibitions: Perhaps Society of Artists, 1783, No. 223

Literature: Greco, *Rowlandson,* I, pp. 262-266; Hayes, John,
Thomas Rowlandson, Watercolors and Drawings, New York,
1972, pp. 50, 77, figs. 12, 13; Paulson, *Rowlandson,* p. 16
Private Collection

The setting for this scene is the Place des Victoires, built
in the seventeenth century by Mansard. By the late eight-
eenth century it occupied what had become the heart of the
trading center of Paris near the Bourse. The scene is domi-
nated by the statue of Louis XIV, erected in 1686 by the
Duc de la Feuillade and destroyed during the French
Revolution. In the statue Fame crowns the Grand Monarch
who stands on a fallen enemy of France. The King wears an
abbreviated Roman costume which reveals the legs of
which he was so proud and which are being regarded by
the soldier at the far left. Borne along in a chariot, an
admirer gazes in rapt adoration at the statue. In the fore-
ground a shoeblack trains a poodle to dance. At the left an
abbé walks with a coquette proceeded by a richly garbed
dwarf woman. At the right a sensible English couple dis-
passionately observes the statue. In front of them an
English mastiff attacks an Italian greyhound. A solitary
monk at the right, a procession of monks, and a pair of
aristocrats in a carriage attended by five footmen com-
prise the rest of the figures.

To prevent his English audience from missing the fact that
the setting is Paris, Rowlandson includes the towers of
Nôtre Dame even though in actuality the cathedral is
three-quarters of a mile away.

This highly finished watercolor is among several that
Rowlandson executed for display at the Royal Academy in
the 1780s. Others include *Vauxhall Garden* (1784), *The
French Review* (1786), and *The English Review* (1786).

The large narrative watercolor was a peculiarly French
genre excelled in by Gabriel de Saint-Aubin and Moreu le
Jeune. What distinguishes Rowlandson's narrative water-
color from those of his French predecessors is the dicho-
tomy between the pretty and the comic — Hogarth filtered
through a French style. In this work, as in others, there is
a series of antitheses. The delicacy of watercolor, the ele-
gance of line, and the charm of certain figures and incidents
are contrasted with the grotesqueness, coarseness, and
comicalness of others. In some of his early works still other
contrasts exist: English versus French, doctor versus
patient, youth versus age, beauty versus ugliness. This
combination of contrasts is very English — we need only
think of Shakespeare's ability to join tragedy and comedy.
But, it also follows one of Leonardo's dicta from his *Treatise
on Painting:* "Beauty and ugliness seem more effective
through one another."

Place des Victoires is characteristic of Rowlandson's tech-
nique. Over a firm, expressive, but undifferentiated line are
applied subtly modulated washes.

Throughout his career Rowlandson made many repetitions and counter-proofs of his drawings. There is a signed and dated 1784 version of the *Place des Victoires*.

50

Gouty Gulston the Antiquarian at Antwerp (ill. p. 109)
Watercolor
279 x 216 mm. (11 x 8¹/₂ in.)
Signed and dated, lower right: *Rowlandson 1797;* titled, lower left: *Gouty Gulston the Antiquarian at Antwerp*
Exhibitions: Los Angeles, Fine Arts Department, University of Southern California, 1955; Los Angeles, Fisher Gallery, University of Southern California, lecture November 19, 1968; Claremont, Harvey Mudd College, *16th Century Drawings to 20th Century Drawings,* 1969
Los Angeles County Museum of Art, Mr. and Mrs. Allen C. Balch Collection (M. 49.15)

"Gouty Gulston," the object of Rowlandson's caricature, is Joseph Gulston (1745-1786), a celebrated English print collector. In this work the corpulent Gulston, bearing two paintings under his arm, carrying a stout walking stick in his hand, and with two statuettes bulging from his coat pockets, peers through a lorgnette at a painting of Susanna and the Elders, hung on the wall of a shop. A beak-nosed man in a cap stands behind him smoking a pipe and ogling the painting. The bare breasted proprietress stands at the left. On the floor and on a shelf are objects of antiquity and statues including a lion's head, a seated woman, a ram, an Egyptian cat sarcophagus, and a seated fat man. On the wall above the painting is a pair of horns. Paintings are tiered at the back.

The face and fat body of Joseph Gulston can be recognized in a copy of a print of 1773 by his wife Elizabeth (fig. 19, from the frontispiece to Volume V of John Nicols' *Illustrations of the Literary History of the 18th Century,* London, 1828). From Nicols, we learn that Gulston was the first child born of the secret marriage of Joseph Gulston, a member of Parliament and a rich banker, and Mericas Sylva, the daughter of an impoverished Portugese merchant. This union, which was only publicly acknowledged after the death of the elder Gulston's mother, formed the groundwork of Miss Clementina Black's novel, *Mericas.*

Upon the death of his father in 1766, Gulston inherited a large fortune. Two years later he began his collection of books and prints. He was known to have been willing to pay any price for a print he desired. He amassed a large number of old master prints, 18,000 foreign and 25,000 English portraits, 14,500 topographical scenes, and 11,000 caricatures, humorous, and political prints, as well as a great number of original caricature drawings. In 1786 financial difficulties arising from his profligate spending and entertaining forced him to auction off his entire collection. He first tried to sell it *en bloc* to the Empress of

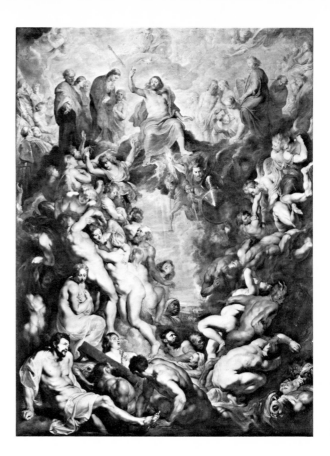

20 Peter Paul Rubens, *The Large Last Judgment,* Alte Pinakothek, Munich

Russia for 20,000 pounds. From a sale that lasted for forty days — from the 16th of January to the 15th of March — he realized only 7,000 pounds.

In his book, Nicols (pp. 33-34) commented on Gulston's gout and corpulence, saying: "... but I am rather inclined to think that his corpulency was brought on by a very injurious habit of swallowing great quantities of small liquids, particularly milk and water." He continues: "He was a fine-boned and small limbed man, five feet ten inches in height. He had his mother's Portugese eyes and had a particular sweetness of countenance."

Gulston, a fellow of the Society of Antiquaries, spent many years compiling a biographical history of all the foreigners who had ever been in England. The unpublished manuscript of this work was included in the auction of 1786.

Rowlandson visited Antwerp in 1794 during a tour of Holland he made with Matthew Michell, the banker. In those years Antwerp was an excellent city in which to purchase art. Nine years earlier, in 1785, the contents of all of the Flemish monasteries had been placed on the market as a result of the confiscation of the monasteries by the French.

Rowlandson's inclusion of allegorical paintings within a picture descends from Hogarth. In several other of his drawings around 1800, such as *The Connoisseurs* in the Paul Mellon Collection (illustrated in Paulson, *Rowlandson*, Pl. 48), he used the theme of Susanna and the Elders to comment ironically on the lasciviousness of old men. In *Gouty Gulston* the two men are very much like the two elders who leer at the nude Susanna. The *Susanna and the Elders* within the drawing is Rubens' painting, now lost but recorded in a print (in reverse) by Vosterman which Rowlandson owned (Rowlandson Sale, 1828, Lot No. 247).

51

The Last Judgment (ill. p. 111)
Pen and ink and watercolor
250 x 204 mm. (9¹³/₁₆ x 8 in.)
Signed and dated (falsely), lower left: *Rowlandson 1786*
Provenance: Christie, Manson & Woods, London, June 16, 1961, Lot 26
Stanford University Museum of Art, Palo Alto, The Mortimer C. Leventritt Fund (69.33)

A close copy of the lower right corner of Peter Paul Rubens' *The Last Judgment* of 1615-1618 in Munich (fig. 20), this drawing differs from Rubens' painting in only one respect. In the lower left corner Rowlandson substituted a tail for the figure of a man which occurs in the painting. Otherwise, the hoofed and horned devil carrying off two nude women, the snake biting one man and strangling a second, the falling nudes and devils, and the various heads are just like their counterparts in the original.

Rubens was Rowlandson's favorite artist if we can judge by his own personal collection. Although he owned twenty prints by Rembrandt, and paintings (probably copies) by Andrea del Sarto, Pordenone, Paris Bordone, Marco Ricci, Joseph Vernet, Van Dyck, and the Teniers, he had well over a hundred prints after paintings by Rubens (Rowlandson Sale Lot Nos. 247-272). These included prints after religious, mythological, historical, landscape, and portrait paintings. In the case of *The Last Judgment,* Rowlandson's collection included a print which Cornelis Visscher had made after the painting (Rowlandson Sale Lot No. 255).

Rowlandson copied Rubens on a number of occasions. The *Susanna and the Elders* which appears in several drawings is just one example (see Cat. 50). What attracted him to Rubens was the robust energy in such paintings as the *Kermesse* and *The Last Judgment,* and Rubens' cannon of female beauty with his lush, ripe nudes.

Like many other eighteenth-century artists, Rowlandson copied works both by older and contemporary artists. His first known copies were of Hogarth's *Five Days Peregrinations* of 1781. Seven years later he published *Rowlandson's Imitations of Modern Drawing* which includes, among others, prints after drawings by Gainsborough, Wheatley, Mortimer, Gilpin, and Cipriani. The Widener Collection, Harvard University, has a number of nude studies after Salviati, Maratta, Boucher, and others. Rowlandson also made drawings of Correggio's *Education of Cupid* (British Museum), and Reynolds' *Fortune Teller* and *Death of Dido* (both in the Wiggin Collection, Boston Public Library).

52

Roman General and Consort (ill. p. 110)
Pen, two tones of brown ink, and watercolor over graphite
181 x 115 mm. (7¹/₈ x 4¹/₂ in.)
Fine Arts Museums of San Francisco, Achenbach Foundation for Graphic Arts (1963.24.550)

From his earliest years Rowlandson copied works by artists whom he admired. Toward the end of his life he began to draw copies of Neo-Classical sculpture by Clodion, work by John Flaxman, and, above all, of classical antiquities. Many of these he copied from engravings. A principal source seems to have been *Les Monuments Antiques du Musée Napoléon* with engravings by Thomas Piroli and text by J. C. Schweighauser of 1804. At least some of his copies were drawn after the original monuments either during his 1814 trip to Paris or his trip to Italy sometime after 1820. Although a direct source for the *Roman General and his Consort* has not yet been found, the presence of the soldier at the left suggests it may be based on a work, perhaps an engraving, by a Neo-Classical artist.

Thomas Sandby
Nottingham 1721-1798 Windsor

Thomas Sandby left his native Nottingham for London in 1742 accompanied by his younger brother Paul, who also became a competent draughtsman. Sandby soon entered the Drawing Office of the Tower and accompanied William, Duke of Cumberland, in his campaigns in Scotland and the Netherlands. Four years after the Duke became Ranger of Windsor Forest, in 1746, Sandy moved to Windsor and later became Deputy Ranger. The Duke's major achievement as Ranger was to construct at his own expense the Virginia Water, an artificial lake occupying about 160 acres. Sandby designed the Rockwork, complete with cascade and grotto, which was placed in the lake. Not only was Sandby a prolific draughtsman, but he was also an architect and served as a professor of architecture at the Royal Academy.

53

Study of an Ash Tree (ill. p. 88)
Pen, grey ink wash, and watercolor over graphite
183 x 118 mm. (7³/₁₆ x 4⁵/₈ in.)
Provenance: William Sandby; Christie, Manson & Woods, Ltd., London, March 24, 1959, Lot No. 18 (with two designs

Rockwork for Virginia Water

21 Thomas Sandby, *Design for Rockwork for Virginia Water,* pen,
black ink, and watercolor over graphite, 183 x 321 mm., Fine
Arts Museum of San Francisco, Achenbach Foundation for
Graphic Arts (1964.137.6)

for Rockwork at Virginia Water)
Fine Arts Museums of San Francisco, Gift of Mr. Anthony
Godwin Hail (1964.137.7)

Artists had drawn studies of individual trees long before
Thomas Sandby produced this simple and charming water-
color of a single ash tree bathed in what appears to be the
sunlight of early afternoon. One of the reasons this work is
interesting is that it reflects the change in taste which
occurred in landscape gardening during the eighteenth
century. At the beginning of the century the formal garden
— originated in France by André le Nôtre and brought to
England by William and Mary — was still in vogue. The
first attack on this formality was leveled at topiary, the
sculpting of trees, by Joseph Addison in *The Spectator,*
No. 414 of June 25, 1712: "Our trees rise in cones, globes
and pyramids. We see the mark of the scissors upon every
plant and bush . . . I would rather look upon a tree in all its
luxuriancy and diffusion of boughs and branches." The
opposition grew swiftly in a series of essays by Addison,
Steele, and Alexander Pope in *The Spectator* and *The
Guardian.* In approximately 1727 the first example of what

would soon be called the "English" garden was created by
William Kent and Lord Burlington at Chiswick House.

During the years that Thomas Sandby worked at Windsor
Forest the main addition was the creation of the Virginia
Water. The Fine Arts Museums of San Francisco has
several watercolor designs by Sandby for the Rockwork
and the grotto (fig. 21).

Francesco Simonini
Parma 1686-1753 Venice

Simonini studied with the obscure battle painter Ilario
Spolverini (1657-1734) and later with Francesco Monti
(1646-1712). As a young man in Florence, he is said to have
copied battle scenes by the seventeenth-century French
painter Jacques Courtois. After visits to Rome and Bologna
he settled in Venice. Like Marco Ricci (1676-1729) he
belonged to a coterie of painters who were trained in the
tradition of Courtois but combined the older master's style
with the lighter tones and manner of the Venetian Rococo.

A Cavalry Engagement (ill. p. 64)
Pen, brown ink, and wash
213 x 311 mm. (8³/₈ x 12¹/₄ in.)
Literature: Los Angeles, *Drawings,* 1970
Los Angeles County Museum of Art; Gift of Art Museum
Council (M.69.58)

This drawing with its friezes of figures engaged in fierce
combat is an interesting combination of two compositional
methods, the High Renaissance pyramidal arrangement
and a method which dates from antiquity in which a second
set of figures is placed in the distance above the foreground
figures. The pyramid in this instance is created by the fore-
ground line of cavalry together with the billowing cloud of
smoke ascending immediately behind them and forming
the apex. The antique influence can be seen in the place-
ment of the second line of infantry which occupies the
incline behind the first group. On the right a steep hill
rises up, and in the far distance a town is visible.

According to Terisio Pignatti (*Eighteenth-Century Vene-
tian Drawings from the Correr Museum,* London, 1965,
No. 69), the large collection of Simonini drawings in the
Correr Museum were executed in two manners: "The first
is sketchy, with dense and dramatic brushwork, flashing
highlights and emphasized contours; the second is more
finished and done mainly in light washes." This spirited
drawing of the second quarter of the century is clearly
executed in the first manner.

Giovanni Battista Tiepolo
Venice 1696-1770 Madrid

Giovanni Battista Tiepolo, the greatest decorative painter
in eighteenth-century Italy, produced a dazzling succes-
sion of brilliantly executed works. Among them were the
Archbishop's Palace at Udine (1726), the Palazzo Labia,
Venice (1740s), the Kaisersaal and Grand Staircase of the
Prince-Bishop's residence at Würzburg (1750s), the Villa
Valmarana, Vicenza (1757), the Villa Pisani, Strà (1762),
and the Royal Palace, Madrid (1762).

Orphaned as an infant, Tiepolo was apprenticed to Gregorio
Lazzarini, and his work was strongly influenced by Paolo
Veronese and Sebastiano Ricci. In 1719 he married a
sister of the painter Francesco Guardi. They had nine chil-
dren, the third of whom, Domenico, became his chief
assistant. Tiepolo went to Spain in 1762 at the invitation
of Charles III and remained there until his death in 1770.

55

Bearded Man in a Cloak (ill. p. 72)
Pen, brown ink, and wash

206 x 140 mm. (8¹/₁₆ x 5¹/₂ in.)
Provenance: Count Corniani degli Algarotti, Venice (?)
(1852); Edward Cheney, Shropshire (?) (1885); Christie's,
London, 1914; E. Parsons and Sons, London (?); Charles E.
Slatkin Galleries, New York
Exhibitions: Santa Barbara, Santa Barbara Museum of
Art, *European Drawings, 1450-1900,* 1964, No. 78; Berkeley,
Master Drawings, 1968, No. 58; Santa Barbara, *Drawings,*
1970, No. 92
Literature: *European Drawings,* 1450-1900, intro. Thomas
Leavitt, Santa Barbara, 1964, No. 78 (ill.); Berkeley,
Master Drawings, 1968, No. 58 (ill.); Santa Barbara,
Drawings, 1970, No. 92 (ill.)
Santa Barbara Museum of Art, Gift of Wright Ludington
(64.12)

A volume of eighty-six single, standing, draped figures by
Tiepolo at the Victoria and Albert Museum, *Sole Figure
Vestite,* includes numerous studies of a bearded man wear-
ing a cloak and hat. The Santa Barbara sheet of a similar
figure probably comes from an album broken up and sold by
the dealer Parsons in the 1920s. Although none of the
figures can be associated with specific paintings, according
to George Knox (*Catalogue of the Tiepolo Drawings in the
Victoria and Albert Museum,* 1960), it is probable that
none can be dated later than the Würzburg period, 1751-
1753.

56

Flying Female Figure (ill. p. 72)
Pen, brown ink, and wash
Inscribed in an old hand, lower left: *rr*
269 x 199 mm. (10⁹/₁₆ x 7¹⁵/₁₆ in.)
Provenance. A. Scharf, London; Paul Drey Gallery, New
York
Exhibitions: Baltimore, The Baltimore Museum of Art,
The Age of Elegance: The Rococo and its Effects, 1959,
No. 217; Indianapolis, Herron Museum of Art, *Old Master
Drawings,* 1962, No. 24; Berkeley, *Master Drawings,*
1968, No. 57
Literature: Baltimore, The Baltimore Museum of Art,
The Age of Elegance: The Rococo and its Effects, 1959,
No. 217; Indianapolis, Herron Museum of Art, *Old Master
Drawings,* 1962, No. 24; Berkeley, *Master Drawings,* 1968,
No. 57 (ill.)
University Art Museum, University of California, Berkeley
(1968.4)

This single figure, seen from below, may be one of a large
group of related drawings called, after the title of an album,
sole figure per soffitti. The provenance of the nine Tiepolo
albums bought by Edward Cheney from Count Algarotti
Corniani in Venice in 1852 is fully discussed by George
Knox in the *Catalogue of the Tiepolo Drawings in the
Victoria and Albert Museum* (London, 1960). The album

containing these single figure studies for ceilings was sold at Christie's in 1914. Parsons, the purchaser, sold off the pages during the 1920s. A pen and wash drawing at the British Museum, *Angel Seated on a Cloud* (illustrated in Detlev, Baron von Hadeln, *The Drawings of G. B. Tiepolo,* Paris, 1929, Pl. 85) is very closely related to the Berkeley sheet.

Giovanni Domenico Tiepolo
Venice 1727-1804 Venice

Giovanni Domenico Tiepolo and his brother Lorenzo (1736-1776) studied with their father, Domenico becoming his chief assistant. From 1750 to 1753 he accompanied his father to Würzburg where they decorated the Archbishop's palace. He was also with him in Madrid working in the royal palace from 1762 to 1770. The style of Domenico's early paintings is nearly indistinguishable from that of his father. It was only in 1757, with the decoration of the Villa Valmarana, that Domenico's special gift as a painter of genre subjects emerged.

In addition to being a painter, Domenico was also an engraver. He produced prints after his father's work as well as many of his own invention such as the series *The Flight into Egypt,* twenty-seven *tour-de-force* variations on a theme, begun in 1750. It is said that he undertook the series to prove his originality of invention. Perhaps the same purpose inspired several series of drawings which sometimes ran to more than a hundred variations on a theme. Among these are *God the Father, Christ Received into Heaven,* the *Assumption of the Virgin, Baptism of Christ,* and *Saint Anthony and the Infant Christ.*

57

God the Father (ill. p. 74)
Pen, black ink, and wash
Signed, lower right: *Dom Tiepolo*
242 x 170 mm. (9^9/$_{16}$ x 6^{11}/$_{16}$ in.)
Provenance: Adolph Loewi Gallery, Los Angeles
Mr. and Mrs. Lorser Feitelson

From a large series on the same theme, this drawing shows God the Father seated on a cloud. He is supported by two angels at the right, at the left by a third angel and four putti, and at the bottom by three angels who are partially hidden. God holds a scepter in his left hand and has a triangular halo. The heads of cherubs appear at the bottom left and in the sky above.

J. Byam-Shaw (*Domenico Tiepolo,* 1962, p. 32) writes that while he knows of nearly sixty drawings of this theme, the old numbering, found in the left-hand top corner of many of them, indicates there may be as many as 102. These draw-

ings are almost invariably signed, as is the Feitelson drawing. All have approximately the same dimensions.

Some of the series (Byam-Shaw illustrates one, Pl. 21, from the Correr Museum) bear a direct compositional relationship to the group of God the Father in Giovanni Battista's great altarpiece, *Saint Thecla Delivering the City from the Plague,* of 1759. This confirms the fact that some of the series were produced in the late 1750s. However, in other series, particularly *Christ Received into Heaven,* Domenico continued to produce variations for nearly twenty-eight years.

Byam-Shaw suggests (p. 32) that Domenico borrowed the triangular halo from the ceiling fresco in the Church of the Pietà in Venice of 1755 on which he collaborated with his father. *God the Father,* like many of Domenico's drawings, shows the artist's concern with creating an active overall surface pattern of lights and shades without creating an illusion of depth.

58

Pulcinello Presides at a Hanging (ill. p. 73)
Black chalk, pen and brown ink and wash, with dark brown and yellow washes
Inscribed, upper left: *98;* signed, lower left: *Dom. Tiepolo fc.;* inscribed top verso: (illegible) *half only* and *Vol. 0 no page*
355 x 470 mm. (14 x 18½ in.)
Provenance: Sotheby's; P. and D. Colnaghi, London; Richard Owen, Paris; Dan Fellows Platt, Englewood, New Jersey; Mortimer C. Leventritt, San Francisco
Exhibitions: Chicago, The Art Institute of Chicago, *Paintings, Drawings and Prints by the Tiepolo,* 1938, No. 110; Berkeley, *Master Drawings,* 1968, No. 61
Literature: Chicago, The Art Institute of Chicago, *Paintings, Drawings and Prints by the Tiepolo,* 1938, No. 110; T. Welton, *The M. C. Leventritt Collection of Far Eastern and European Art,* Stanford, 1941, No. 278; D. M. Mendelowitz, *Drawing,* New York, 1967, 95, figs. 4, 15; Berkeley, *Master Drawings,* 1968, No. 61 (ill.)
Stanford University Museum of Art, Palo Alto, Mortimer C. Leventritt Collection (41.278)

The comic figure Pulcinello, always up to pranks and jokes, was created in Naples in the early seventeenth century and became a stock character of the *Commedia dell'Arte.* By the mid-eighteenth century the hump-backed, beaked-nosed Pulcinello with his white suit, ruff, tight trousers, and sugar-loaf hat was a commonplace in Venice. Domenico's father, Giovanni Battista Tiepolo, a master at caricature, made several drawings of Pulcinello, and Domenico made him the basis for the frescoes he did for the family villa at Zianigo.

Late in his life Domenico produced a series of 104 draw-

ings, including a title page, devoted to the life of Pulcinello. On the title page Domenico wrote "Divertimento per li Regazzi" — An Entertainment for Children. He may have intended to have the drawings engraved, but no engravings exist. The drawings follow no known text, but the general drift of the story is clear. J. Byam-Shaw has pointed out that the series falls into several groups, related in theme: Pulcinello's ancestry; his childhood and youthful amusements; his trades and occupations; his adventures in strange lands; his social and official life; his illness and death (Byam-Shaw, *Domenico Tiepolo,* 1962, pp. 57-58).

Pulcinello Presides at a Hanging is numbered 98 at the upper left but according to a reconstruction of the series should be number 95 in the series. According to Byam-Shaw's categories, the Stanford drawing is a scene from Pulcinello's official life. He is seated on a horse, holding a sword and presides at the execution. Isolated on a hillock from the other figures, he looks out, like an actor delivering an aside to the audience. The composition is dominated at the right by the gallows and the limp figure of the hanged man. Below are a crowd whose attitude is one of rather idle curiosity.

The artist was in his late sixties when he made this drawing. But his mastery is still evident in the thin, descriptive line and in the vitality of the lights and shades which run from the very dark, abstract shadow of Pulcinello and his horse to the speckled wash on the horse.

Nicolaas Verkolje
Delft 1673-1746 Amsterdam

Nicolaas Verkolje studied with his father Jan Verkolje (1650-1693). Originally a portrait painter, he later painted historical, religious, and genre subjects. He was also a master mezzotint artist. The seventeenth-century Dutch artists Gérard de Lairesse, Adriaen van der Werff, and Gabriel Metsu were all strong influences on Verkolje. His early paintings reveal a knowledge of French academy painting, but as transmitted through van der Werff. His later paintings are more strongly influenced by earlier seventeenth-century art. Hints of the English artists Geoffrey Kneller and Peter Lely can be detected in his portraits.

59

Time Unveiling Deceit (ill. p. 54)
Pen, grey ink, and wash over red chalk
365 x 387 mm. (14⅜ x 15¼ in.)
Literature: Sacramento, *Master Drawings,* 1971, p. 165
The E. B. Crocker Art Gallery, Sacramento (202)

The allegorical figures in Verkolje's drawing would have been easily identifiable in the eighteenth century. Seated upon clouds before a porticoed temple is the figure of Truth. On her head is a small sun; in one hand she holds a mirror and in the other an open book. Behind her, holding a child, is the figure of Charity. In the center the figure of Time, winged and with raised scythe, unveils the crouching figure of Deceit who hides behind a mask. With his right leg Time holds down the figure of Discord. Behind Time is the personification of Perspicacity, Pallas Athena, also symbolized by the sphinx. At the far right, fleeing, is the figure of Envy, eating a heart.

In this drawing Verkolje reveals his allegiance to the allegorical tradition of late seventeenth-century Dutch art and particularly to the works of Gerard de Lairesse, author of the academic textbook on painting, *Het Groote Schilderboek.* One of his many engraving commissions led him in 1731 to produce prints after the seven paintings Lairesse made for the townhall in The Hague.

Typical of Verkolje's style is the contrast between the softly rounded bodies highlighted with darts of light and the crisply angular draperies. The drapery treatment reflects a response to French art as transmitted by his father and other Dutch artists. Traces of French academic painting are also evident in the decorative relief-like composition. This was of such concern to Verkolje that to maintain the shallow depth he distorted the perspective of the portico.

Andries Vermeulen
Dorchecht 1763-1814 Amsterdam

Vermeulen, who studied with his father, Cornelis (c. 1732-1813), specialized in winter landscapes, particularly skating scenes with many figures. He also made a number of drawings after Albert Cuyp.

60

Skating Scene (ill. p. 99)
Pen, brown ink, grey wash, touches of gouache
383 x 543 mm. (15⅛ x 21⁷⁄₁₆ in.)
Provenance: Sotheby & Co., London, June 8, 1972, No. 63
Private Collection

The details in this large, highly finished drawing are recorded with great precision. Vermeulen goes so far as to include even the scratches made on the ice by the skates. He records a profusion of activities: a man and small boy elegantly skating in the center, children and adults sledding at the left, other skaters in the distance behind the central figures, and at the right under a Dutch flag a temporary tavern. At the far right is a touch reminiscent of the lusty works of Jan Steen, a man relieving himself on the ice.

Vermeulen's panoramic view of life on the frozen river

shows the direct continuation of a seventeenth-century theme into the late eighteenth century. Like Jan van Goyen, Hendrik Avercamp, and his fellow Dordrecht predecessor Albert Cuyp, Vermeulen was interested in recording both the teeming activity of people and the majesty and drama of the Dutch winter sky. The proportions of the earth and sky — roughly one third to two thirds — are similar to those in the works of the earlier artists.

François André Vincent
Paris 1746-1816 Paris

Vincent's father, François Elie, was a miniature painter who wanted his son to enter the world of business. However, the painter Joseph Marie Vien (1716-1809) succeeded in persuading the father to allow Vincent to become his pupil. In 1768 Vincent won the coveted *Prix de Rome,* and he spent the years from 1771 to 1776 in Rome. In 1782 he was elected a member of the Academy and in 1792 became a professor. Primarily a history painter, Vincent exhibited at the Salon from 1777 until 1801 and at the Salon de la Correspondence in 1782. His popularity rivaled that of Jacques-Louis David, and like David he did not lose either popularity or position after the French Revolution. When the Institute was reorganized, he was made one of the first members. He also became a professor of drawing at the Ecole Polytechnique and was awarded the *Legion d'honneur.*

<hr>

61

Woman at a Window (ill. p. 93)
Sanguine with a trace of red chalk
Paraph of Vincent in iron gall ink, lower center
184 x 160 mm. (7¼ x 6⁵⁄₁₆ in.)
Provenance: Barneker S. Achenbach
Fine Arts Museums of San Francisco, The Achenbach Foundation for Graphic Arts (1963.24.312)

This drawing with its firm contour lines which seem spontaneously to capture the pensive mood of the heavy figure was formerly attributed to Fragonard. According to Phyllis Hattis (in her forthcoming catalogue of French drawings in the Fine Arts Museums of San Francisco), the drawing actually has less in common with Fragonard than with other artists active in the mid-eighteenth century. Her attribution to Vincent is convincing, and she suggests that it was drawn shortly after the artist returned to Paris from Rome in 1776. The paraph of Vincent in the lower right supports the attribution.

Antoine Watteau
Valenciennes 1684-1721 Nogent-sur-Marne

After studying with a local painter, Watteau moved to Paris in 1702. To support himself he worked for the dealer Metayer making copies after seventeenth-century Dutch

22 Antoine Watteau, *Concert Champêtre,* engraved by B. Audran, 1735

paintings. Between 1704 and 1708 he studied with the painter Claude Gillot who was greatly interested in the theater, and in 1708-1709 with Claude Audran. His brief association with Audran was influential because during that time he was able to study closely Peter Paul Rubens' *Life of Marie de Medici* cycle in the Luxembourg Palace where Audran had his apartments. In 1709 he won second prize at the Academy and returned to Valenciennes. In Paris again, around 1712, he went to live with the collector Pierre Crozat. In 1717 he was admitted to the Academy; his acceptance piece was *The Embarkation from Cythera.* His health, always delicate, worsened in 1719, and he went to London to consult the famous Dr. Mead. Like Raphael, Watteau died at the age of 37. Scholars have divided his career into three periods: early (1705-1712), early maturity (1712-1717), and maturity (1717-1721).

<hr>

62

Study of Two Men Playing Musical Instruments
(ill. p. 52)
Red and black chalk
213 x 171 mm. (8⅜ x 6⅝ in.)
Provenance: Sotheby & Co., London, Nov. 26, 1970, Lot 59; H. Shickman Gallery, New York
Private Collection

23 Antoine Watteau, *The French Comedians*, The Metropolitan
Museum of Art, The Jules S. Bache Collection, 1949

The *Study of Two Men Playing Musical Instruments* is a
preparatory drawing for the painting *Concert Champêtre,*
which is now lost. It is recorded, however, in an engraving
by B. Audran (fig. 22) which was included in the first vol-
ume of M. de Jullienne's *L'Oeuvre d'Antoine Watteau* pub-
lished in 1735. According to the text accompanying the
print, the painting was then in the collection of a Monsieur
Bougi. Later in the century Pierre Mariette was even more
specific, saying that it was the owner who was repre-
sented, "jouant de la basse de viole." Further attempts at
identifying Monsieur Bougi are unconvincing (G. Schefer
— in "Les Portraits dans l'oeuvre de Watteau," *Gazette
des Beaux-Arts,* II [1896], p. 177 ff. — claims he is either
Guillaume-Joseph de Croissy, "seigneur de Bougy" and
"conseiller au Parlement de Rouen" or Jean-Jacques
Révérend de Bougy, Marquis de Colognes).

The chronology of Watteau's drawings and paintings is

much disputed, but the majority of them were created
within the second decade of the century. In the case of
figure studies, often as many as ten years elapsed between
a preparatory drawing and a painting. In this instance the
drawing was probably a study from life which only later
was incorporated into a painting in a different context. In
the painting the man wears contemporary dress whereas
in the drawing he is wearing a striped outfit. Such multi-
striped clothing appears in several of Watteau's paintings,
including *L'amour du Théâtre italien* in Berlin and
Mezzetin in The Metropolitan Museum of Art.

63

*Head of a Man Wearing a Wig and a Tricorne; Two Studies
of Hands (ill. p. 53)*
Black and red chalk
166 x 241 mm. (6⅞ x 9⅞ in.)

Provenance: Mme. La Comtesse de Behague, Paris; Thomas Agnew, London; Louis C. G. Clarke, London; Sir David Eccles, London; M. Jean Davray, Paris; Harry A. Brooks, New York; M. Knoedler, New York

Exhibitions: London, P. and D. Colnaghi, *Exhibition of Old Master Drawings,* April 6-May 14, 1948, No. 33; London, Matthiessen Gallery, *French Master Drawings of the 18th Century,* October-November, 1950, No. 110; London, Royal Academy, *European Masters of the Eighteenth Century,* November 27, 1955, No. 232; London, Royal Academy of Arts, *France in the Eighteenth Century,* 1968, No. 767

Literature: Sotheby & Co., *Catalogue of Important Drawings of Old Masters . . . also . . . the Property of Madam the Comtesse de Behague,* London, June 29, 1926, No. 123 (ill. facing p. 33); Colnaghi and Co., *Exhibition of Old Master Drawings,* London, 1948, No. 33 (ill. as frontispiece); Copley-Sargent, "Full Swing in the London Season," *Art News,* 49 (1950), p. 42; Royal Academy, *European Masters of the Eighteenth Century,* London, 1954, No. 232; K. T. Parker and J. Mathey, *Antoine Watteau,* Paris, 1957, Vol. II, p. 343, No. 753 (ill. fig. 753); Douglas Cooper, *Great Private Collections,* New York, 1963 (ill. p. 256); London, Royal Academy of Arts, *France in the Eighteenth Century,* 1968, No. 767

The Norton Simon Foundation, Los Angeles

According to K. T. Parker and J. Mathey, the model who posed for the gentleman also appeared in a drawing in the Musée Jaquemart-André (*Antoine Watteau,* Paris, 1957, Vol. II, No. 940, ill.). They suggest he was the actor Jullienne, who is the central male figure in *The French Comedians,* in The Metropolitan Museum of Art (fig. 23). On the basis of the style, they date the two drawings to the artist's period of relative maturity (c. 1716).

Watteau was the eighteenth century's master of the nuance. His sensitivity and skill allowed him to represent subtle differences of texture such as that in the softness of the face, the buoyancy of the wig, and the wrinkling of the skin of the wrist in the hand at the right. Watteau captured the sensuousness of the flesh in the shading of the face and hands by wiping the red chalk lightly with a moistened finger tip. His skill is particularly evident in his ability to combine such softly modeled passages with incisive accents such as those that delineate the eye and nose.

Benjamin West
Springfield 1738-1820 Rome

Upon the death of his mother in 1756 Benjamin West moved to Philadelphia. There his portraits, largely the product of self-training, prompted local merchants to send him to Italy in 1759. He visited Rome, Florence, Bologna, and Venice; in Rome he was friends with Anton Raphael Mengs, Gavin Hamilton, and Johann Joachim Winckelmann. In 1763 he went to London intending only a brief visit, but his immediate success encouraged him to remain in England. In 1768 he played a leading role in the formation of the Royal Academy, and he became its president in 1792 upon the death of Sir Joshua Reynolds. In 1772 he became historical painter to King George III having produced in the 1760s such paintings as the *Choice of Hercules* and *Agrippina and her Husband's Ashes,* works of serious themes from ancient history. His *Death of Wolfe* in the 1770s challenged convention by portraying a recent historical event in contemporary costume. During the 1780s his projects, done for the King, were monumental in scale and were based on subjects from English history, Shakespeare, and the Bible.

64

Sight (ill. p. 100)
Pen, brown ink, and wash
Signed and dated, lower middle: *B. West 1784*
170 x 228 mm. (6⅝ x 9 in.)
Provenance: H. Shickman Gallery, New York
Private Collection

In 1968 the H. Shickman Gallery exhibited another West drawing, *Sound,* nearly identical to *Sight* in dimensions and also signed and dated 1784 (illustrated in *Exhibition of Old Master Drawings at H. Shickman Gallery,* New York, 1968, No. 52). Both of these drawings are from a series, the *Five Senses,* which West drew to be engraved by Charlotte Augusta Matlida, the eldest daughter of his patron, King George III.

This drawing of a woman gazing out to sea shows West at his finest as a draughtsman. The rapid and varied lines explore shapes; dots are used to indicate shading on the face; and the wash not only captures the plasticity of the figure but also creates a dramatic pattern of light and shade.

65

Study for Saint Michael and the Dragon (ill. p. 106)
Pen and brown ink
212 x 183 mm. (8¹⁵⁄₁₆ x 7⅛ in.)
Provenance: Adolph Loewi Gallery, Los Angeles
Literature: The Frederick S. Wright Art Gallery, University of California, *The Grunwald Center for the Graphic Arts, Twenty Years of Acquisition,* Los Angeles, 1974, No. 155
Grunwald Center for the Graphic Arts, University of California, Los Angeles (1971.221)

One of Benjamin West's most active patrons in the 1790s was William Beckford. In 1796 Beckford had commissioned

24 Benjamin West, *Saint Michael and the Dragon*, 1797, Toledo Museum of Art

25 Benjamin West, *Study for Saint Michael*, 1770s, black chalk, 145 x 75 mm., The Pierpont Morgan Library (1970.11.215)

In this preparatory drawing West was searching for solutions to compositional problems. The saint's arms are raised, and in his right hand he holds a banner. Below and at the right are clouds to suggest the heavenly setting of the battle. It is the positioning of the saint's right leg which most troubled West. Obviously none of the four possible solutions indicated in the drawing pleased the artist since the placement of the leg is quite different in the painting. Furthermore, both legs are more severely foreshortened in the painting to compensate visually for the intended placement of the window high in the wall. In addition, the banner is left out and the placement of the arms is changed slightly.

There are two earlier versions of the same subject by West. One, dated 1776, is in the collection of James H. Ricau, Piermont, New York, and the other is at Trinity College, Cambridge. (Both are illustrated in Millard F. Rogers, Jr., "Benjamin West and the Caliph: two paintings for Fonthill Abbey," *Apollo*, 83 [1966], p. 424, figs. 4 and 5.) Both of these versions were directly inspired by Guido Reni's famous painting of Saint Michael. One of the preparatory drawings for the Trinity College painting is in the Morgan

the architect James Wyatt to build him a Neo-Gothic residence, Fonthill Abbey. It was the largest home in England before the untimely collapse of the enormous central tower which destroyed most of the house. By 1808 Beckford had purchased seventeen paintings by West, among them *Saint Michael and the Dragon* of 1797 (fig. 24) for which this drawing is a study. The painting is a cartoon for a stained glass window which was intended for the Saint Michael's Gallery of the Abbey but which seems never to have been executed.

Library (fig. 25), and two others are in the collection of Swarthmore College. In all of these, as well as in the Grunwald drawing, West followed hallowed academic practices, drawing the saint nude even though he is fully clothed in the paintings.

The renewal of interest in stained glass windows was an outgrowth of the taste for the Neo-Gothic which emerged in the second half of the eighteenth century. Sir Joshua Reynolds designed a window in 1781 for New College, Oxford, and West in the same decade designed a window for the Saint George Chapel at Windsor Castle.

Jacob de Wit
Amsterdam 1695-1754 Amsterdam

De Wit began his artistic career as a student of Albert van Spiers (1666-1718). At the age of thirteen he moved to Antwerp to live with his uncle, a wealthy art collector. There he studied with Jacob van Halle (1672-1750) and also copied Rubens, Van Dyck, and other Flemish painters. Returning to Amsterdam in 1716, he quickly became one of the most fashionable painters in Holland. Because he was a Roman Catholic, he also received a number of large, religious commissions. These and his numerous decorative commissions resulted in his considerable international reputation — he was known as the Boucher of the North. His sketches for ceilings, known as *witjes,* and his many finished drawings reveal his ability as an artist in the international Rococo decorative style. De Wit's most sig-nificant commission was the enormous scene of *Moses Choosing the Seventy Elders* for the Town Hall of Amster-dam in 1735-1737. A decade later he published *Teekenboek der Proportien van't Menschelijk Lichaem* with engravings by Jan Punt and Stolker after his academy-based drawings.

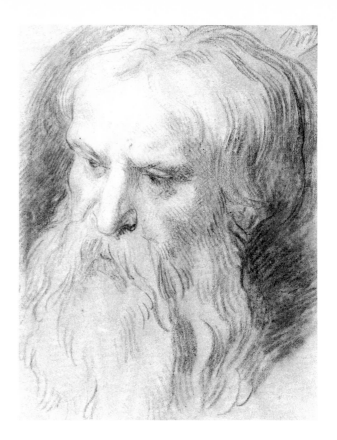

26 Jacob de Wit, *Head of a Bearded Man,* black chalk, heightened with white gouache on blue-green paper, 293 x 228 mm., The E. B. Crocker Art Gallery, Sacramento

66

Allegory of Commerce (ill. p. 61)
Pen and brown ink over graphite
Signed, at the bottom: *J. d. Wit invt.*
116 x 330 mm. (4³/₄ x 12 in.)
Provenance: Ploos van Amstel, Amsterdam; H. Shickman Gallery, New York
Private Collection

The *Allegory of Commerce,* probably a preparatory draw-ing for a decorative commission, shows four young children surrounded by symbols of commerce. At the left are two bales, a pulley, and two weights (?). The child covered by a cloak holds a long handled pan, while another child grasps the caduceus, an attribute of Mercury, god of commerce. Mercury's winged hat rests on the edge below. Behind the group are two bales, at the right a keg and a third weight (?).

The curved bottom edge of the drawing suggests it is a study for an overdoor. Because in many of de Wit's full room decoration the wall panels were monochromatic and often imitated stone reliefs, it can be deduced that if a com-pleted painting exists, it is probably in grisaille. The tech-nique of shading with parallel lines further suggests that the drawing may have served as a model for an engraving.

In his early years in Antwerp, de Wit made a number of copies in chalk after paintings by Rubens (fig. 26). His later drawings, much looser and freer in style, have a sure-ness, lightness of touch, and elegance worthy of the best Rococo artists. The rapid and fluid pen strokes of the *Allegory of Commerce* resembles works of the late 1730s and early 1740s.

Januarius Zick
Munich 1730-1797 Ehrenbreitstein

A versatile and prolific artist, Januarius Zick was active as a frescoist and altar painter primarily in Upper Swabia. His first training was as a student of his father, Johann Zick (1702-1762). He visited Paris, Basel (in 1757), and Rome where he studied with Anton Raphael Mengs (1728-1779) whose Neo-Classicism influenced Zick's later work. He also studied with Bergmüller in Augsburg where he was

elected a member of the Academy. In 1759 Zick assisted his father in the fresco decoration of the palace at Bruchsal and from there was called to serve the elector of Trier. In 1762 he settled in Ehrenbreitstein, and later he directed both the restoration and decoration of the Benedictine church at Wiblungen (1778-1781).

Like Jean Baptiste Greuze whom he occasionally resembles, Zick was familiar with the Dutch cabinet painters of the seventeenth century. This influence is readily apparent in his two oil paintings at the de Young Museum in San Francisco, *Morning at the Farm* and *Mid-Day Meal.*

67

Lazarus and the Rich Man (ill. p. 67)
Pen, brown and grey ink washes heightened with white on blue paper
180 x 292 mm. (7$\frac{1}{16}$ x 11$\frac{1}{2}$ in.)
Exhibitions: Sacramento, *The German Masters,* 1939, No. 64; Berkeley, *Master Drawings,* 1968, No. 26; Sacramento, *Master Drawings,* 1971, No. 87
Literature: Sacramento, *The German Masters,* 1939, No. 64; Berkeley, *Master Drawings,* 1968, No. 26 (ill.); Sacramento, *Master Drawings,* 1971, No. 87 (ill.)
The E. B. Crocker Gallery, Sacramento (77)

The parable in Luke XVI:19-31 in which a rich man feasts with his brothers while a poor man is set apart forms the basis of the subject matter of Zick's finished Lazarus drawing. Lazarus' ultimate spiritual victory, however, is implied by the nobility of his form and the grandiloquence of his gesture.

Ribbons of ornamental stonework and cartouches, characteristic of Rococo designs originating in Augsburg at the mid-century, unify the Venetian sumptuousness and theatricality of the setting and its Mannerist spatial treatment. The catalogue of the Berkeley exhibition suggests that the drawing may be dated to the late 1750s because the ornamental embellishment resembles stucco-work done by Zick and his father at Amorbach during this time. No painting of the subject by Zick is known.

Antoine Coypel
Two Female Figures, Draped

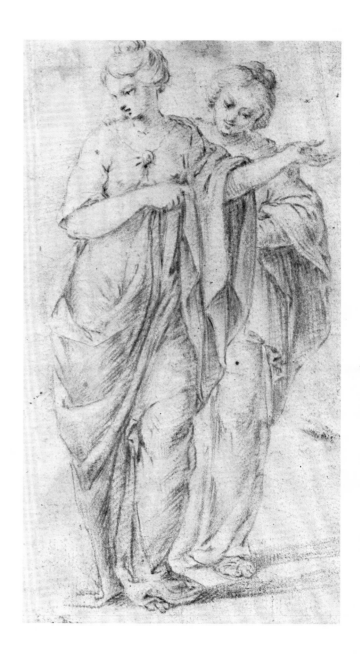

Claude Gillot
Scene of Sorcery

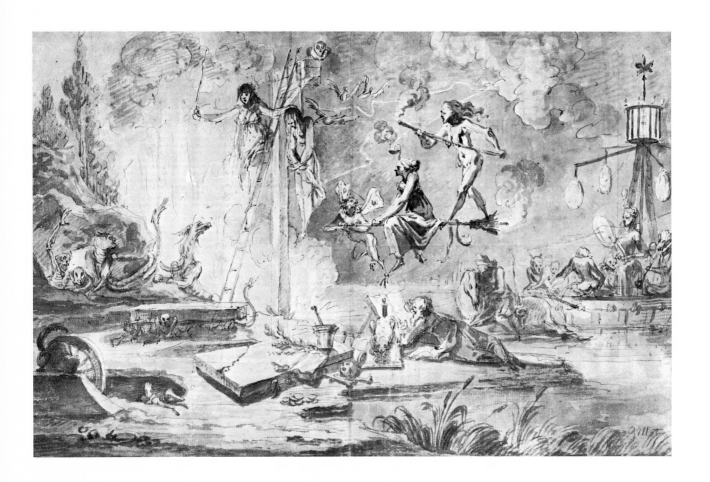

François Lemoine
Head of Omphale

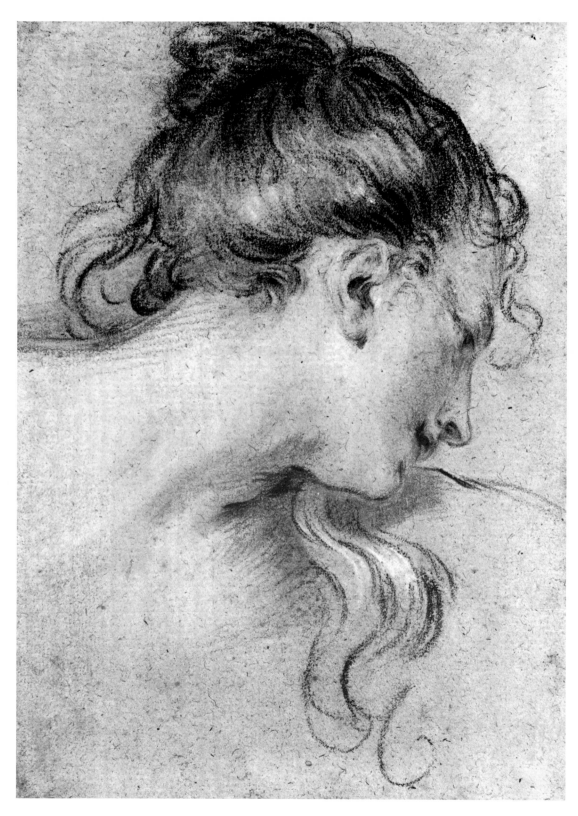

Antoine Watteau
Study of Two Men Playing Musical Instruments

Antoine Watteau
Head of a Man Wearing a Wig and a Tricorne; Two
Studies of Hands

Nicolaas Verkolje
Time Unveiling Deceit

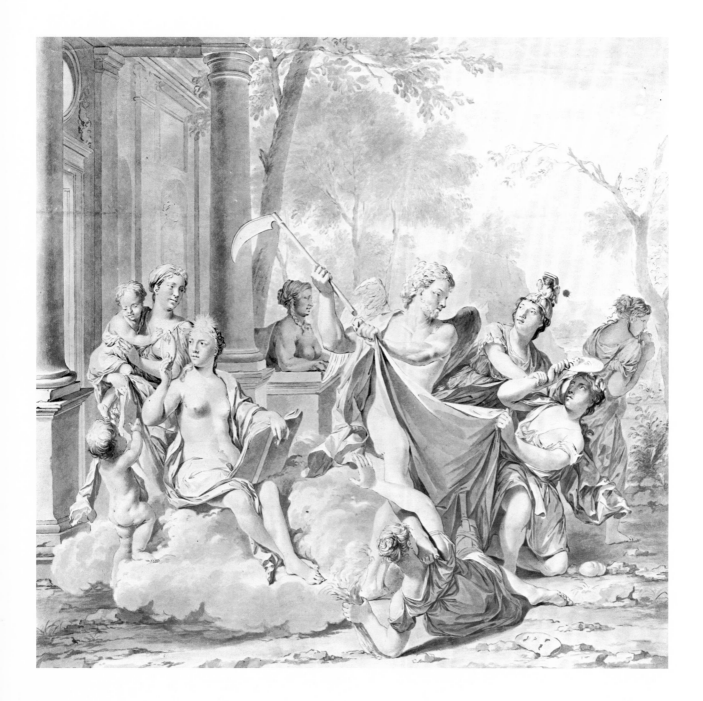

Johann Georg Bergmüller
St. Martin Appealing to the Virgin

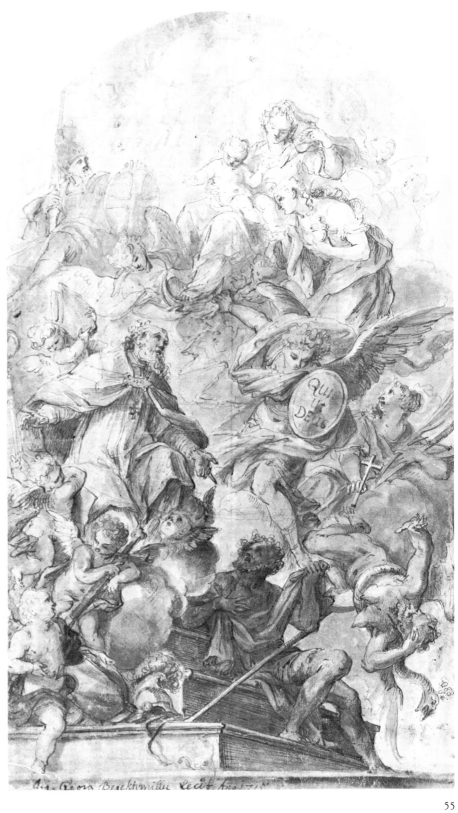

Filippo Juvarra
Tempietto

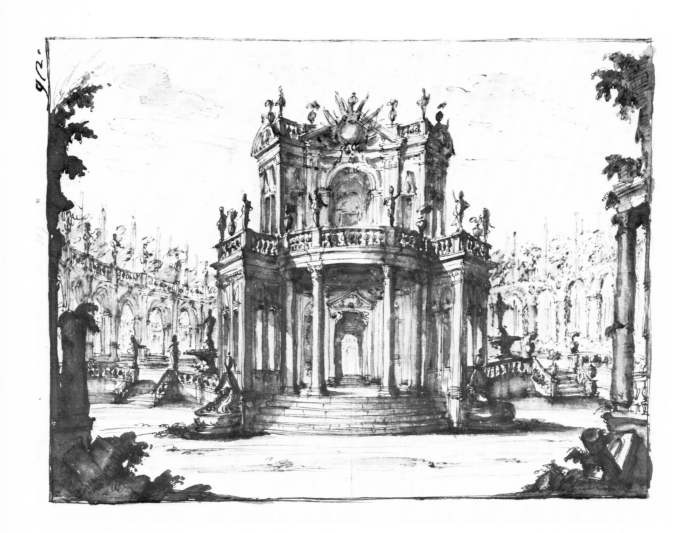

Francesco Galli Bibiena
Architectural Scene

Federico Bencovich
Portrait of a Man

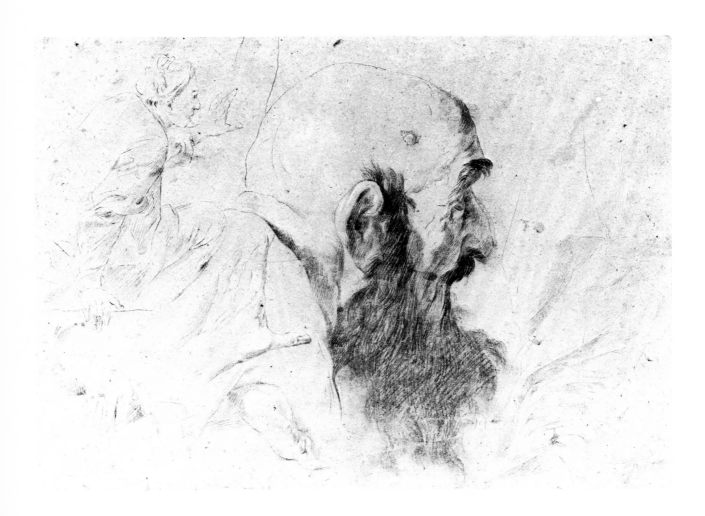

Pier Leone Ghezzi
Caricature of a Gentleman

Nicolas Lancret
Figure of a Gentleman

Jacob de Wit
Allegory of Commerce

Johann Evangelist Holzer
Adoration of the Shepherds

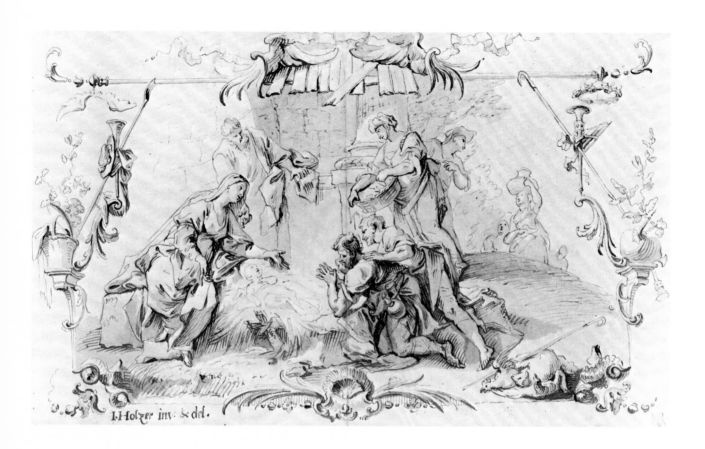

J. Holzer inv. & del.

Johann Wolfgang Baumgartner
Elementum Terrae (Allegory of Earth)

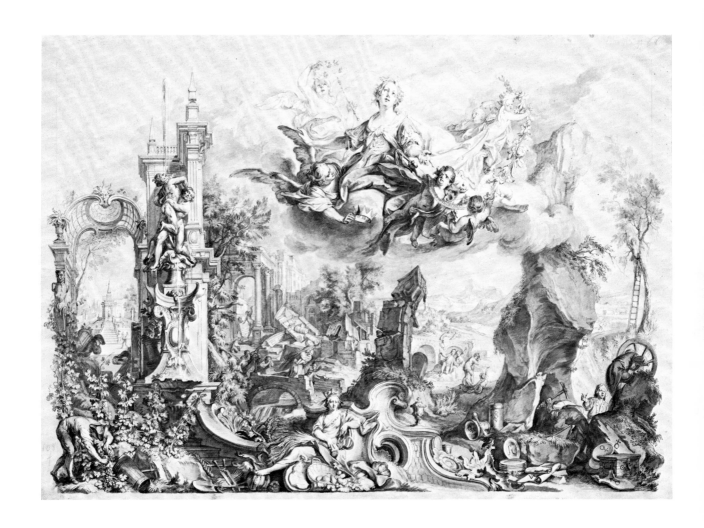

Francesco Simonini
A Cavalry Engagement

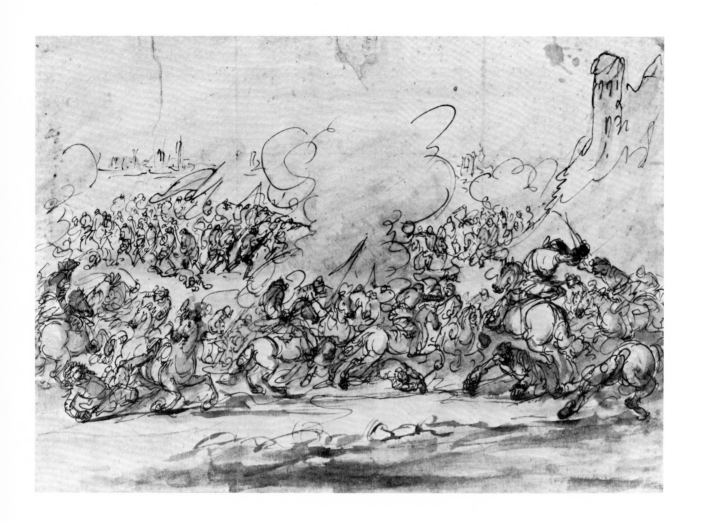

Jean Joseph Benard (Bernard)
A Visit of King Stanislas Lesczinski to the Atelier of Jean Lamour at Nancy

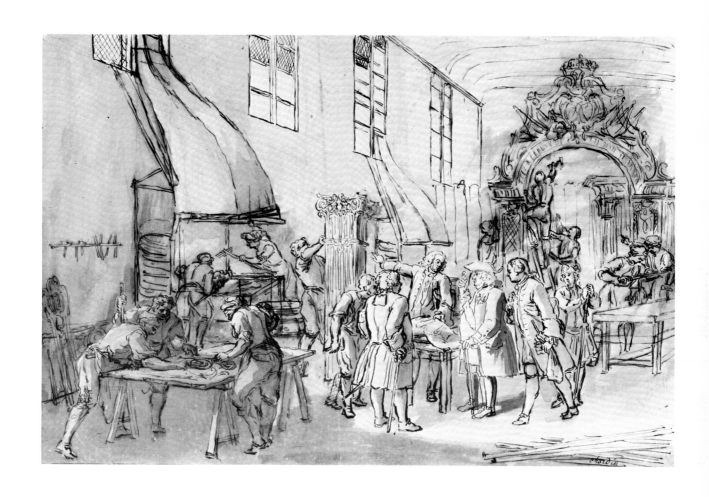

François Boucher
Head of a Roman Soldier

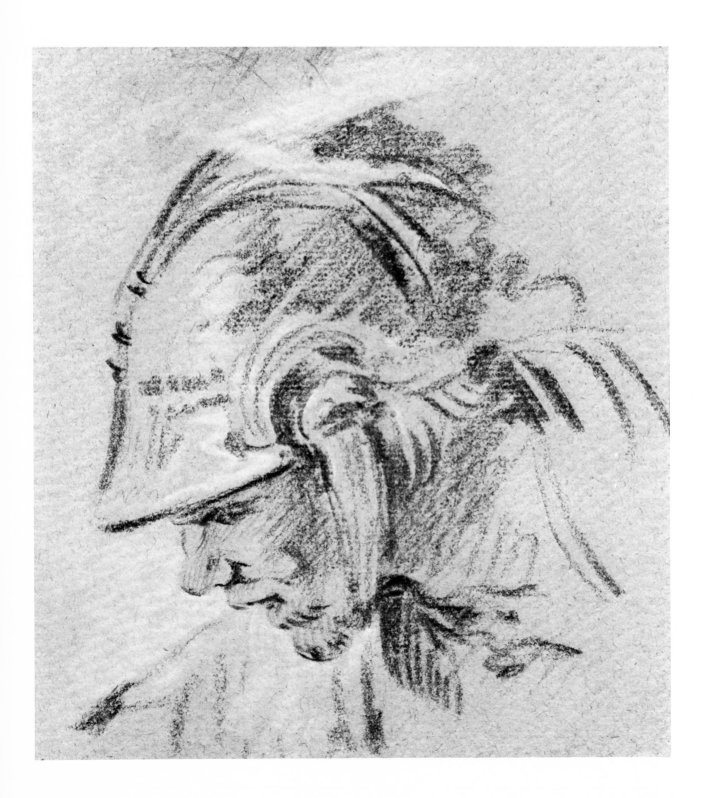

Januarius Zick
Lazarus and the Rich Man

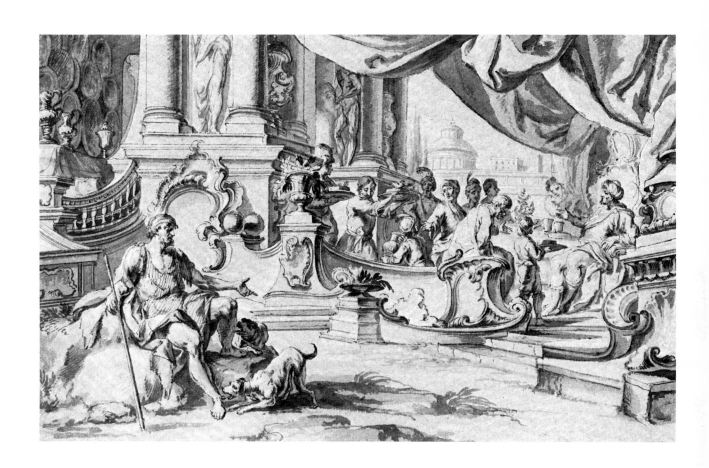

François Boucher
Design for an Overdoor Decoration

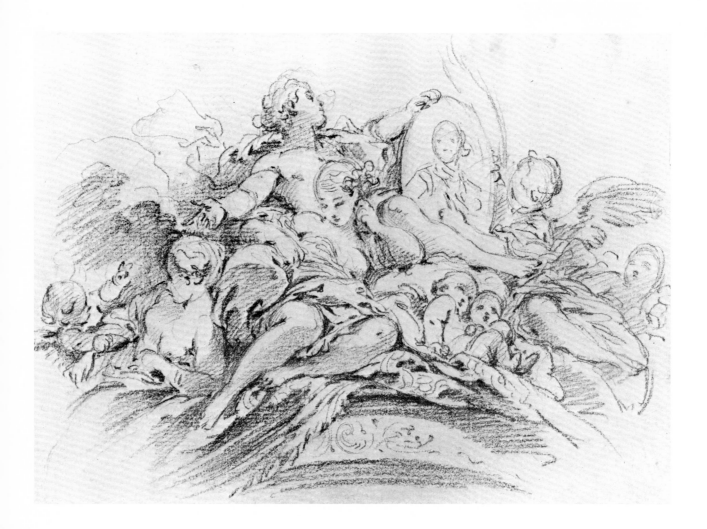

François Boucher
Landscape with a Boy and a Dog

Gravelot (Hubert-François Bourguignon d'Anville)
*Three Preparatory Studies for the Frontispiece to the
Second Canto of Voltaire's* La Pucelle d'Orléans

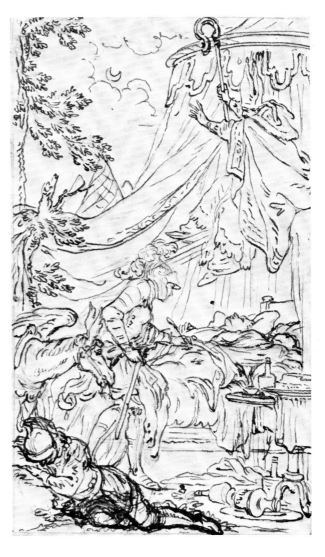

Giovanni Battista Tiepolo
Bearded Man in a Cloak

Giovanni Battista Tiepolo
Flying Female Figure

Giovanni Domenico Tiepolo
Pulcinello at a Hanging

Giovanni Domenico Tiepolo
God the Father

Hubert Robert
View of Tivoli

Hubert Robert
Old Fountain and Pyramid of Cestius, Rome

Jean-Honoré Fragonard
The Banquet of Antony and Cleopatra (after G. B. Tiepolo)

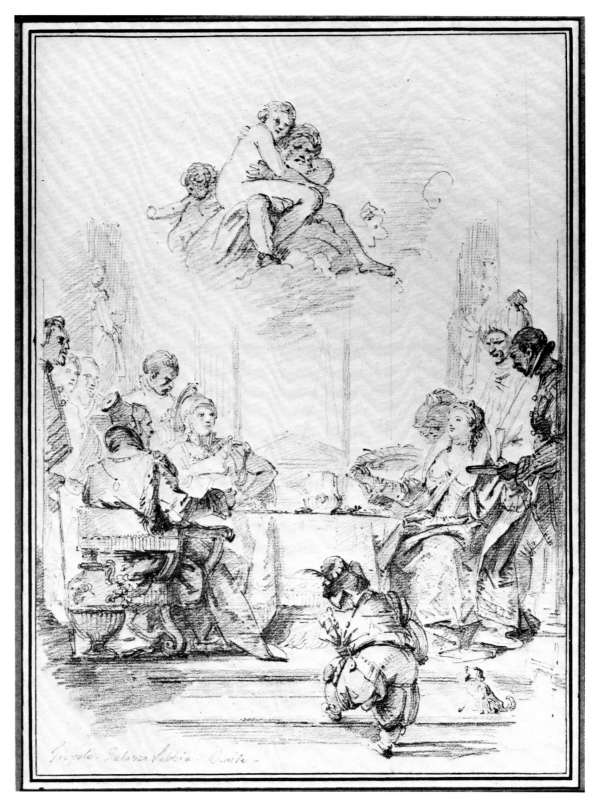

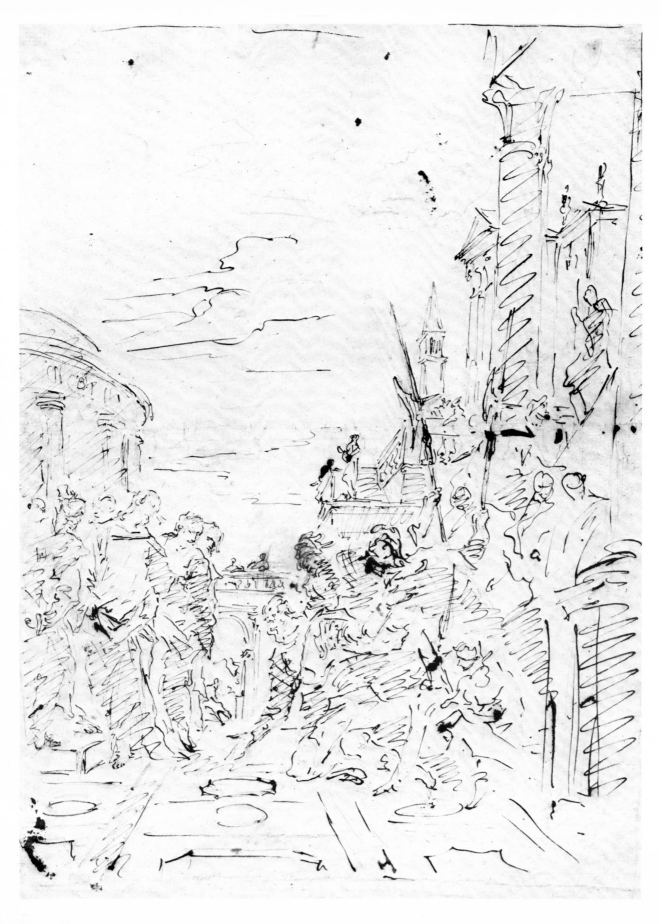

Francesco Guardi
Christ and the Centurion (after Veronese)

Jean-Honoré Fragonard
Adoration of the Magi (after Veronese)

Jean-Honoré Fragonard
An Italian Park

Anonymous French, late eighteenth century
Castle and House

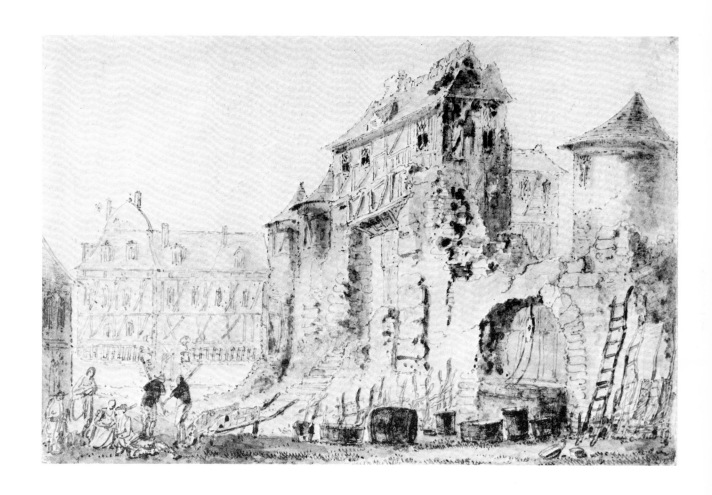

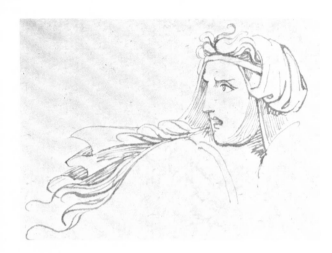

Ubaldo Gandolfi
Martyrdom of a Bishop

Charles-Nicolas Cochin
Portrait of François-Emmanuel Pommyer, Abbé de Bonneval

Dessiné par C-N Cochin à Gandelu le 29 Mars 1771

LE PAYSAN DE GANDELU.

Vertueux, plein de sentiment, l'honneur est son seul élément,
patron de l'innocence. il est sa récompense.

Nicolaas Muys
Portrait of a Woman in a Bonnet

Jean-Baptiste Le Paon
A Prince Ploughing with Peasants Watching Him

Hendrik Kobell
The Dutch Fleet off Batavia

Thomas Sandby
Study of an Ash Tree

Thomas Gainsborough
Upland Landscape with Figures, Riders, and Cattle

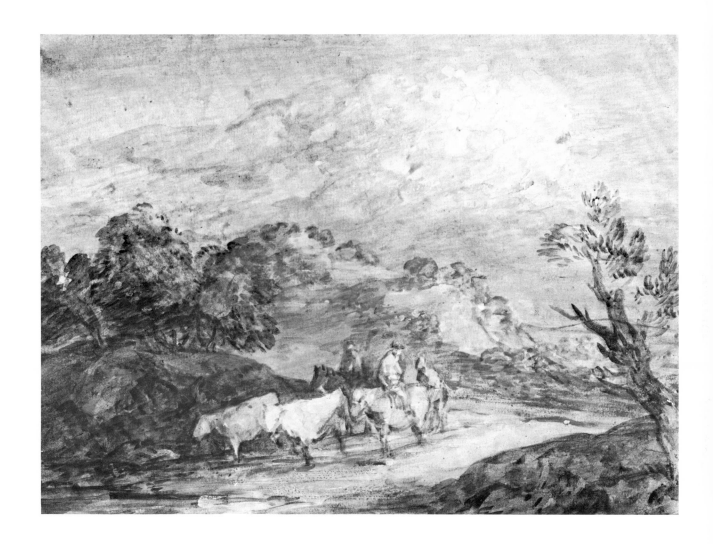

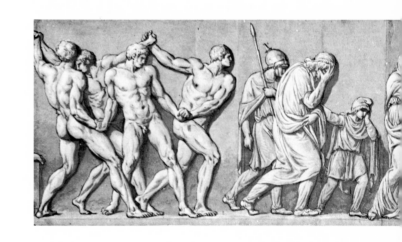

Jacques-Louis David
Funeral of a Warrior

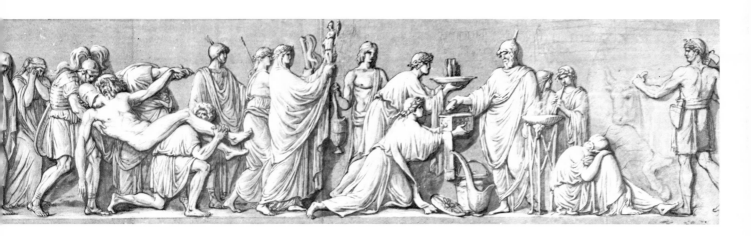

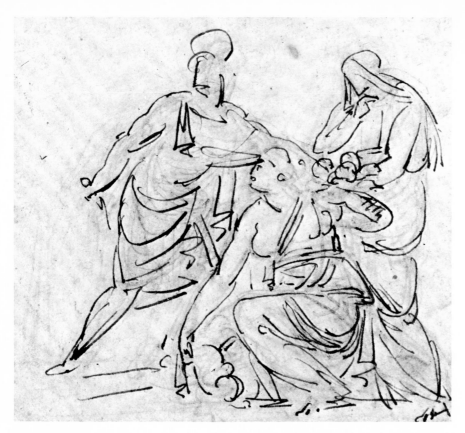

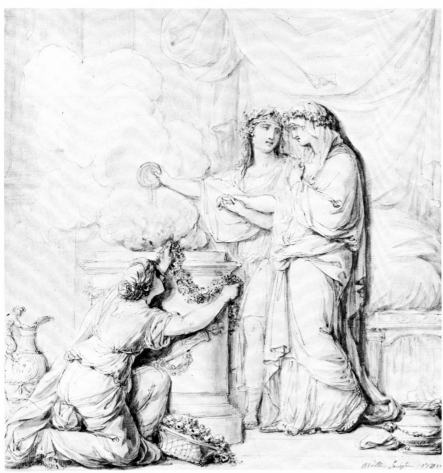

19
42
61
School of David
Jean-Guillaume Moitte
François André Vincent
Death of Camilla
Ritual Marriage Preparation
Woman at a Window

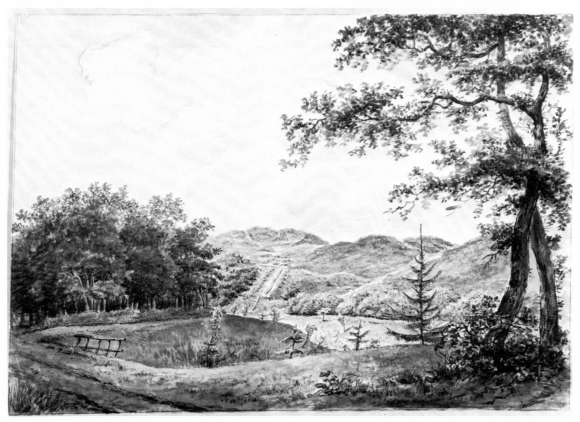

94

41

45

34

Jean-Baptiste Le Prince
Landscape with Shepherds

Johann Friedrich Ludwig Oeser
Landscape

Jean-Baptiste Huet
A Poppy Plant

Daniel Chodowiecki
The Improvement of Morals

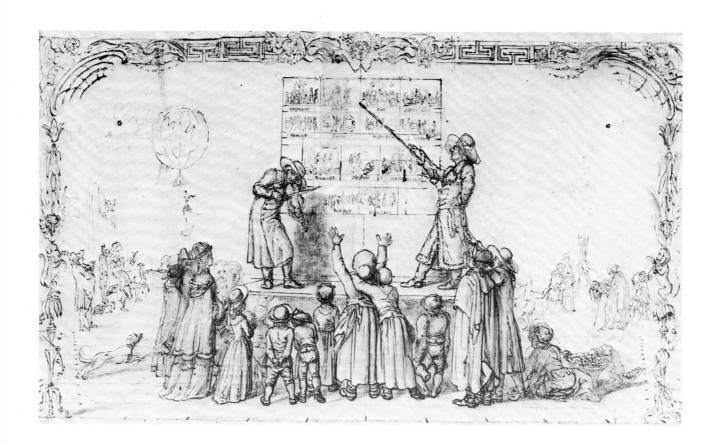

Thomas Rowlandson
Place des Victoires

Andries Vermeulen
Skating Scene

Benjamin West
Sight

George Romney
The Fiend Conjured Up by Bolingbroke

46 a.P.

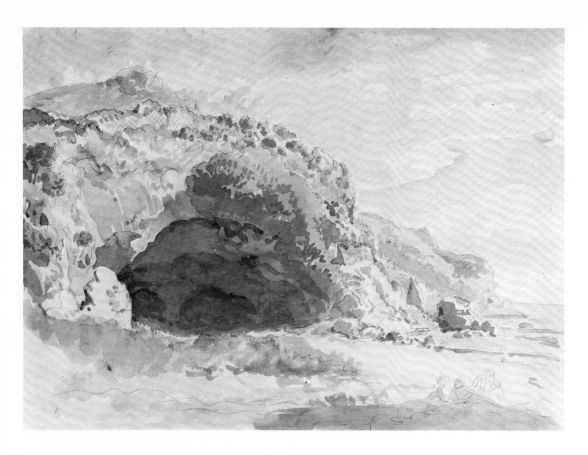

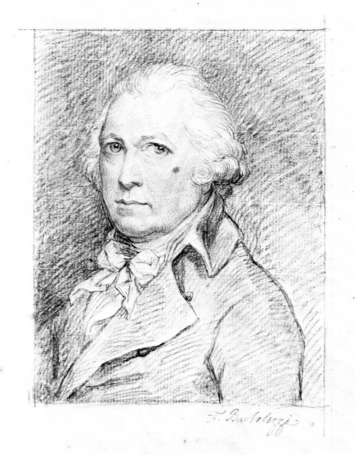

Anonymous German, late eighteenth century
Prophet Addressing Roman Soldiers

by Dandré Bardon (P. Rosenberg)

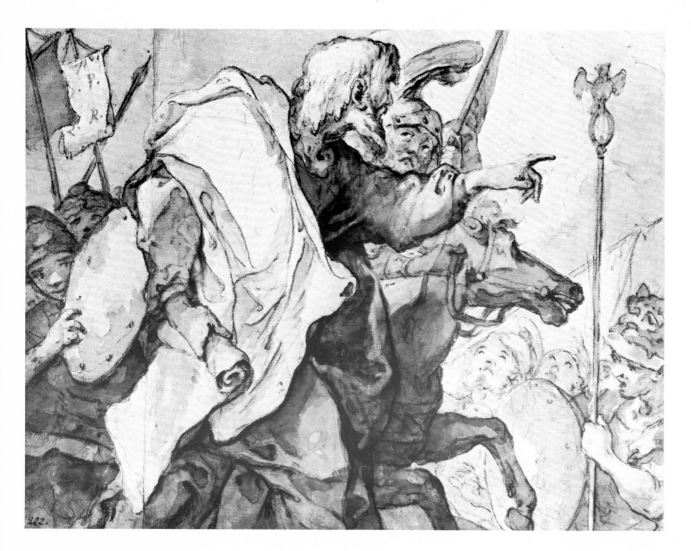

Richard Earlom
Study of a Seated Male Nude Grasping a Staff

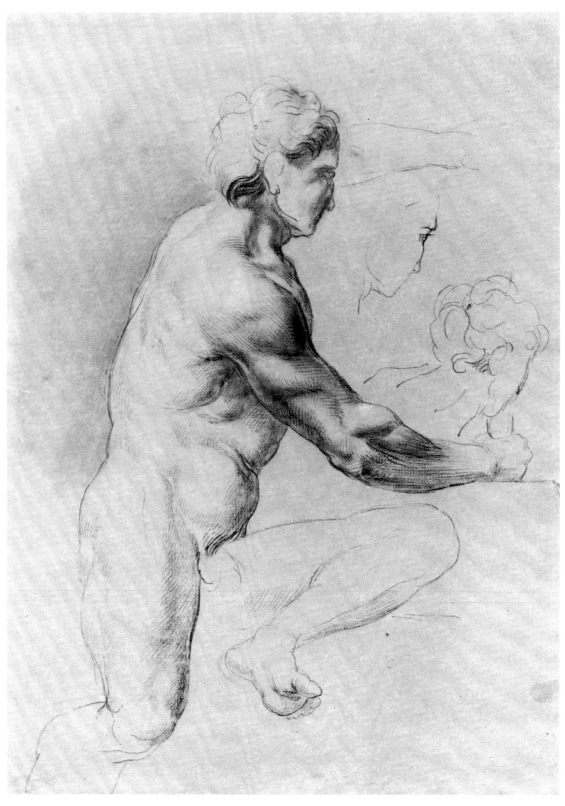

Benjamin West
Study for Saint Michael and the Dragon

Giuseppe Bernardino Bison
Warrior Astride a Centaur

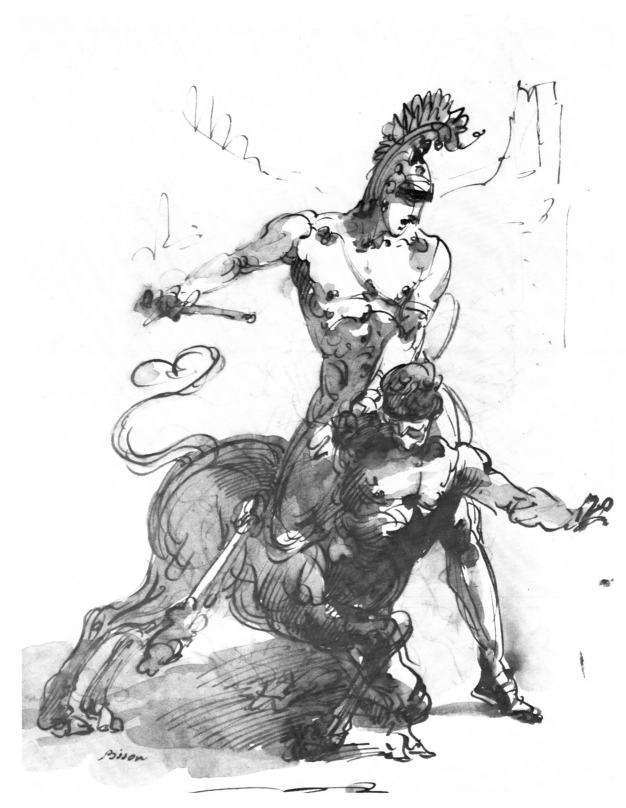

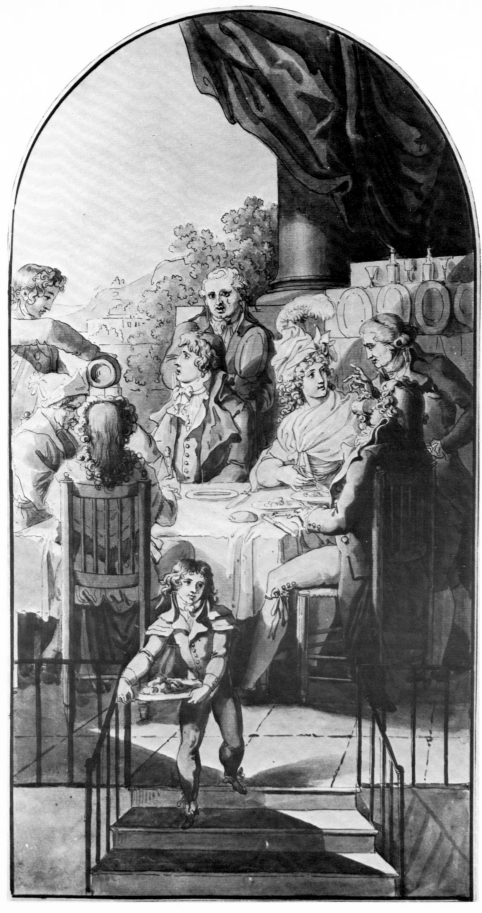

Thomas Rowlandson
Roman General and Consort

Roman General and his Consort — Rowlandson

Thomas Rowlandson
The Last Judgment